IMAGES
*of America*

# THE NORTH SHORE
# OF O'AHU

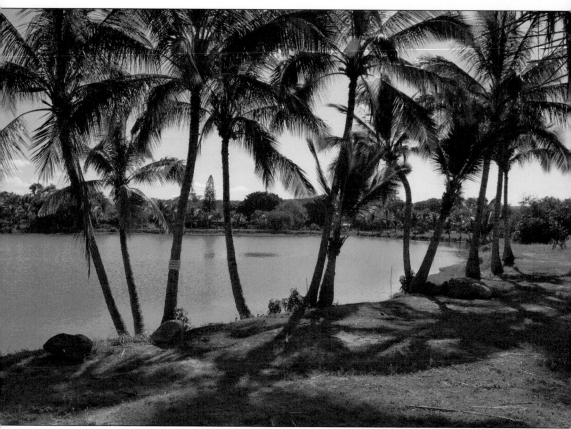

This is Loko Iʻa, a man-made, inland fishpond located in Haleʻiwa. It was most likely constructed by Hawaiians in the late 1700s. Fish from such ponds were often reserved for royalty. (Author's collection.)

ON THE COVER: This photograph of a group of plantation workers was taken in the late 1800s. It demonstrates that at least five different ethnic groups were involved in the primary effort. (Courtesy of the Hawaiʻi State Archives.)

IMAGES
*of America*

# THE NORTH SHORE
# OF O'AHU

Joseph Kennedy

ARCADIA
PUBLISHING

Published by Arcadia Publishing
Charleston, South Carolina

Printed in the United States of America

Library of Congress Control Number: 2010942496

For all general information, please contact Arcadia Publishing:
Telephone 843-853-2070
Fax 843-853-0044
E-mail sales@arcadiapublishing.com
For customer service and orders:
Toll-Free 1-888-313-2665

Visit us on the Internet at www.arcadiapublishing.com

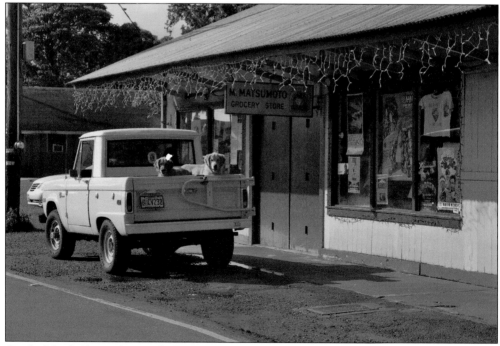

On the North Shore, dogs in the back of trucks are as common as surfboards on the tops of cars. (Author's collection.)

# CONTENTS

# ACKNOWLEDGMENTS

Every book—and especially one such as this—is the work of many people. Because only one name goes on the title page, it is appropriate to mention all those whose contributions made this product come into existence.

Patty Lai and the friendly staff at the Hawai'i State Archives were very helpful, as were the staff members at the National Archives in College Park, Maryland, and those at the Library of Congress in Washington, DC. Dr. Matt Kester of Brigham Young University–Hawaii was as accommodating as possible and granted friendly access to the school's treasure trove of images. Dr. Warren Nishimoto and his staff at the University of Hawai'i's Center for Oral History allowed me access to their valuable collection, and my thanks also go out to the Hale'iwa Surf Museum. The staff at the Hawaiian Historical Society was very helpful, as was that at the Hawaiian Mission Children's Society. Martha Yent at the Division of State Parks was there with a helping hand when called on, and Colin Perry at the Hawaii Aviation Preservation Society opened his photographic collection for use in this book. The US Army Tropic Lightning Museum and the staff at www.Footnote.com were especially accommodating.

I owe a particular debt of gratitude to those individuals who allowed me into their private lives by making family photo albums available to me and oftentimes in their homes. Author, surfer, and current president of the Hawaiian Historical Society, John Clark was wonderfully helpful, and the same goes for Barbara Ritchie and her family. Mike, Becca, and Murph Dailey are cut out of this same cloth, and I am proud to count them as my friends as well as collaborators on this work. Mark Warren and the other mates at Quiksilver in Sydney, Australia, came to my rescue by providing the outstanding photographs of the Eddie Aikau Contest in Waimea. Carter Allan, Bob Leinau, Sean Woolky, Gay Timon, Malia Laniau, and Joe Green offered assistance, and Rick Rogers was especially helpful and generous. Special thanks go out to the Matsumoto, Miura, Kawamata, and Lunasco families. Finally, I would like to thank Etsuko Yoshifuku for her graphic support and Dennis Callan, whose big brain, vast experience, and cutting-edge technological equipment saved me at the eleventh hour. And of course thanks to my wonderful editor, Debbie Seracini of Arcadia Publishing, for her dedicated support and encouragement.

# INTRODUCTION

The North Shore of Oʻahu is a place marked by human epochs, and each one is quite different from the wave that came before. One constant is that it always has been a rural place that has set itself apart from other areas on the island, and throughout time it has been inhabited by various groups whose lifestyle has recognized and maintained the value of what is now referred to as simply "the country."

Like country folk around the world and throughout history, various North Shore populations have understood the beauty of their home not just for its distance from urban crowding and for its quiet and natural charms, but also for the way of life that seems to come as a by-product of living on this land. It can be said that for more than 1,000 years and for 40 generations of people from disparate ethnic backgrounds, the North Shore of Oʻahu has always been a region marked not just by its rustic definition—but also because it is a state of mind.

It has a unique temperament and a personality that is defined by place, and these qualities have survived through the rather dramatic changes that have visited the North Shore in the past 200 years. Hawaiian farmers and fishermen first set the tone in the initial wave of settlement; explorers recognized it and wrote about it, while sugar and pineapple workers along with railroad men and cowboys (or *paniolo*) lived it and continued to blend it into their particular manners and customs.

Planters of diversified agricultural products, polo players, merchants, writers, craftsmen, soldiers, and surfers have all played a part in the prolongation of this country mind-set. It seems as if the North Shore of Oʻahu itself is the defining agent that keeps the continuum going; this and the significant stamp of the Hawaiian founder population that continues to permeate the spirit of those who came after them.

The North Shore is unique and recognized as being so by people around the world, but it is also unique to the island on which it exists. At a time when there are nearly one million people on the island of Oʻahu, the North Shore has somehow maintained its distinctive and rural nature, and in a rapidly changing era it continues to sustain the blended traditions of the past and retain its singular flavor.

The first Westerner to lay eyes on the North Shore was Capt. James Cook and his crew in 1779. It was the first part of the island of Oʻahu to be seen by a white man. At that time, the Hawaiians had been established on the island for more than 1,000 years and had created a complex and highly developed social system. Under that arrangement, what we now call "the country" was comprised of one of the island's six districts (or *moku*) known as Waialua, and part of another known as Koʻolauloa, and it stretches from Kaʻena Point to Lāʻie.

Around 1430, Waialua was ruled by a chief named Laʻakona from a power base known as Lihuʻe that was located in the ʻEwa District, probably somewhere near the present-day Schofield Barracks. In other words, in the early days, the ruler of most of the North Shore came from somewhere else, and from this, we can make a number of inferences. First, it may well have been that for quite a while Waialua was a land that did not have a great population base nor strong chiefs, and as a consequence it was susceptible to dominance by outside forces. As we shall see, this will be a recurring theme throughout the history of the North Shore. Next, it suggests that there were things about Waialua and Koʻolauloa that were coveted.

By 1630, a female chief named Kekela ruled over all of Waialua, and included in her holdings were also the portions of Koʻolauloa that comprise the rest of what we know call the North Shore.

Later, Kekela's nephew married her and took Waialua into his independent kingdom, but the point is that the rulers of the North Shore still came from somewhere else.

By the early 1780s, the rule of O'ahu chiefs over the area known as the North Shore gave way to another outside ruling body—this time from the island of Maui under Kahahana and, later, Kahikili. But the Maui rule of the North Shore ended about a decade later when a Hawai'i chief, Kamehameha the Great, defeated them in a seminal battle in Nu'uanu Valley in 1795.

It was around this time that we see powerful chiefs and kahuna (or priests) being resident on the North Shore and the development of monumental architecture, which included extensive taro fields and important ceremonial centers. Kamananui in Waialua became the political center, and through great effort Anahulu Valley was converted into an enormous taro basket. Additionally, several large, inland fishponds were built, the largest *heiau* (or temple) on the island was constructed above Waimea Valley and named Pu'u o Mahuka, another called Kupopolo was erected nearby, the important Kapukapuakea heiau was established at Kaiaka, and the Kukaniloko complex was elaborated. If all this were not enough, Kamehameha the Great's primary spiritual advisor, a man named Hewahewa, established residency in Waimea Valley. This very influential and powerful man could have selected almost any location on any island as his home, but Waimea was his choice. The North Shore was suddenly becoming a very important place.

The powerful chief Kaopulupulu, who built the *luakini* (or human sacrifice) heiau Pu'u o Mahuka, was himself a sacrificial victim at another temple with the same function near Diamond Head, and it was no more than 50 years after the death of Kamehameha the Great that ownership of the land began falling into the hands of still other people whose roots were located in places other than the North Shore. As we have seen, first the chiefs from 'Ewa were in control, next the North Shore's rulers came from Maui and later Hawai'i; but soon, and at the height of its importance, the new owners of North Shore lands would, for the first time, not be Hawaiian.

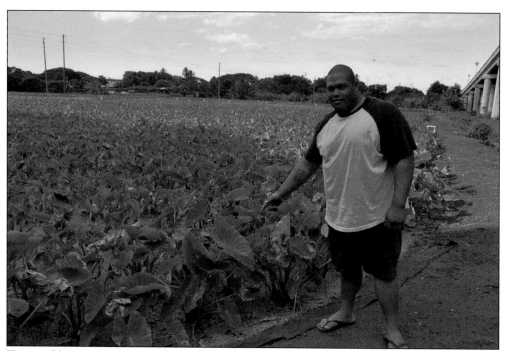

Taro is oldest crop on the North Shore, and the corm of this plant is the source of poi. Here a local gentleman points to his plants at the site of a newly developed taro plantation in Hale'iwa. (Author's collection.)

# One

# THE INITIAL WAVE
## HAWAIIANS,
## THE FOUNDER POPULATION

In order to understand the North Shore, it is important to know something about the lives of the founder population that lived here for 1,000 years before the Hawaiian Islands were discovered by non-Polynesians. Archaeologists are unsure of the actual date someone first set foot on the island of Oʻahu or built the first home on the North Shore. It is known, however, that it was Polynesians who did so in both instances. They came from the south in great double-hulled canoes, probably from the Marquesas, Tahiti, Cook Islands, and other island groups. Many of their voyages were purposeful and guided by the stars, and most of them stayed when they got here. The initial settlement of Oʻahu seems to have taken place between the years 300 and 600, and modeling has suggested that perhaps another 100 years may have passed before any appreciable population was present on the North Shore.

If early census and archaeological data are used to estimate how many people were living on the North Shore during its heyday, the number of people living in an *ahupuaʻa*, which were native land divisions within districts, gives a good estimate. By the 1700s, reasonable population estimates are roughly 500 people living in these land units, and because the North Shore contained 25 ahupuaʻa, it can be assumed that there were more than 10,000 Hawaiians living on the North Shore around 1800. But soon those numbers would decline drastically due to imported diseases, and by 1850 the North Shore Hawaiian population probably numbered closer to 5,000.

The people who made the North Shore their home back then subsisted on crops mostly brought to Hawaiʻi by their ancestors, which were masterfully cultivated over time, and by fishing. They lived in grass huts often built on raised rock foundations and mostly in extended family groupings rather than traditional villages. They worshiped a pantheon of personal and collective gods, paid taxes, were family oriented, lovers of sports, song, and dance, celebrated humorists, and remarkable environmentalists. Theirs was a simple life that not only complemented their surroundings, but also one that began a tradition of place.

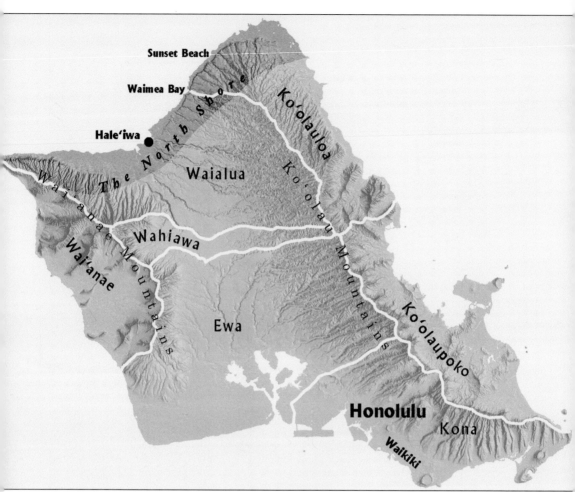

On this map of the island of Oʻahu, the North Shore is shaded, and selected landmarks are added for reference. This map also depicts the ancient districts, or moku boundaries. (Courtesy of Ev Wingert.)

This etching, done on the Cook expedition in 1778, is entitled *A Man of the Sandwich Islands*. It depicts a young chief wearing a feathered helmet and cape that was emblematic of his rank. (Courtesy of the Hawai'i State Archives.)

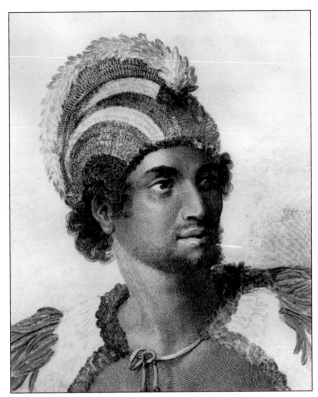

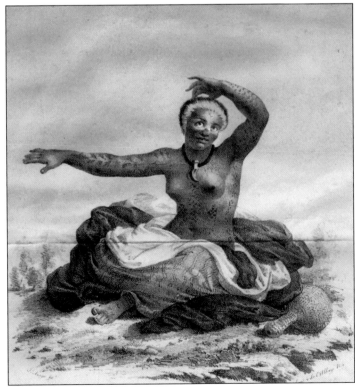

A female chief performs a hula in the seated position. The carved whalebone pendant around her neck is called a *lei niho palaoa*. This pendant is strung on thousands of finely braided strands of human hair. These significant lei were worn by the highest *ali'i*, or chiefs, of both genders. (Courtesy of the Hawai'i State Archives.)

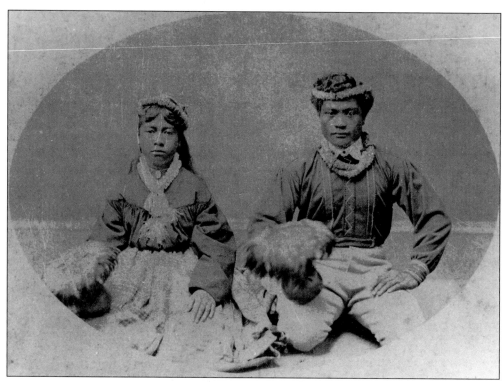

Dancers pose before the camera with traditional gourd instruments sometime between 1860 and 1920. (Courtesy of the Hawai'i State Archives.)

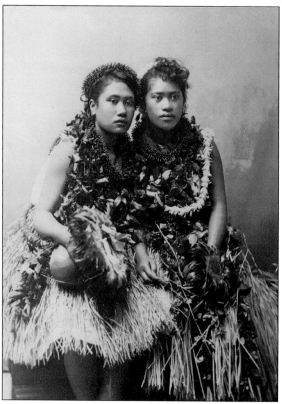

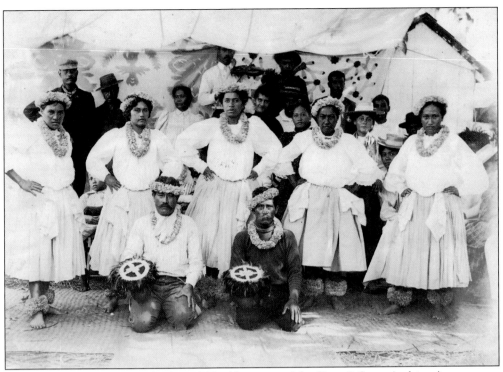

A hula troupe is on tour in the late 1800s. (Courtesy of the Hawai'i State Archives.)

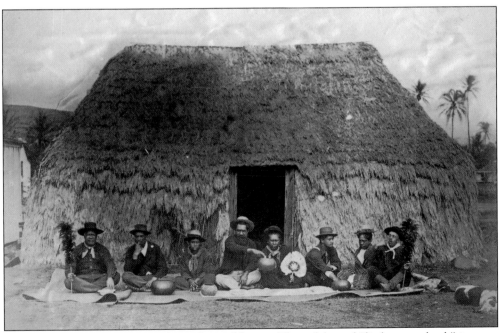

This group is seated in front of a traditional house. The celebrated "little grass shack" is not a myth. Most Hawaiians lived in family clusters composed of these types of residences that ranged from grotty to grand depending on the owners' status, the wealth of their land, and the chiefs who ruled it. (Courtesy of the Hawai'i State Archives.)

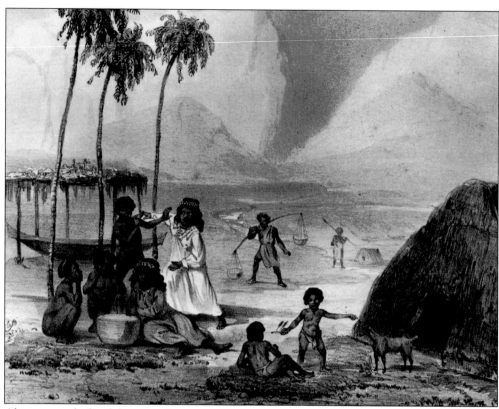

Above is an idealized drawing of a Hawaiian domestic scene, and below is an early photograph of one partial example. Most Hawaiians lived in modular compounds composed of separate houses for eating, sleeping, and cooking, a men's house, a women's house, and so forth. (Courtesy of the Hawai'i State Archives.)

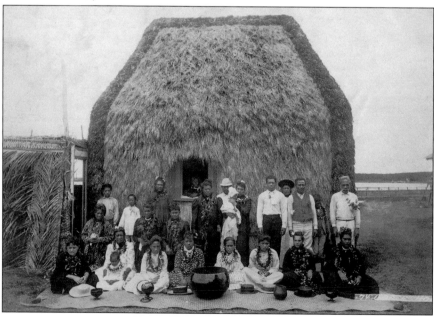

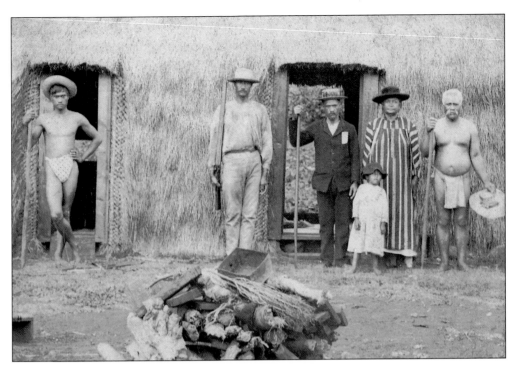

Above is an 1800s photograph of a group of Hawaiians, and below is one of the original petitions for a land claim in order to "officially" secure ownership of their property under the new Western system of land tenure. (Courtesy of the Hawai'i State Archives.)

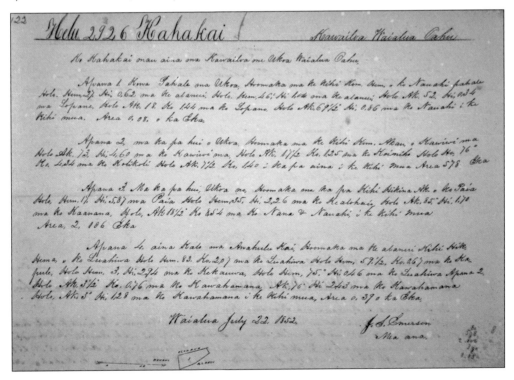

By the mid-1800s, under the new Western system of fee simple ownership, barely two percent of the commoners in Hawai'i were able to resettle on lands once under the control of their families and chiefs. (Courtesy of the Hawai'i State Archives.)

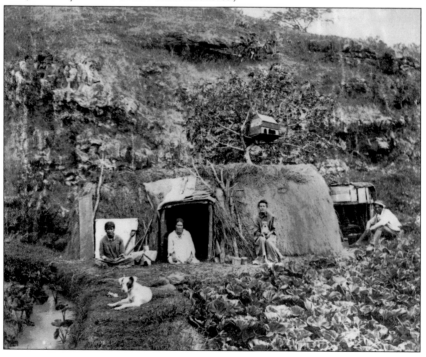

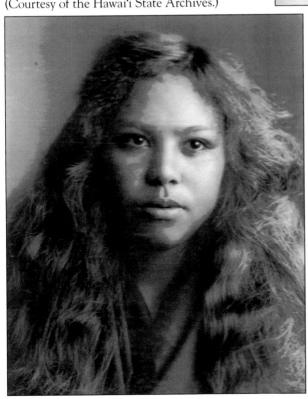

At right is an early drawing of an ali'i, in this case a woman of rank as indicated by her carved whale-tooth pendant, or lei niho palaoa. When the first white men landed on the North Shore on Sunday, February 8, 1779, Captain King wrote, "[W]e found but a few of the Natives, and those mostly Women, who prostrated themselves as we Went along." It is unlikely any female chief would have done this. Below is an early photograph of a young Hawaiian woman who may have reversed the situation by having the sailors prostrating themselves before her. (Courtesy of the Hawai'i State Archives.)

17

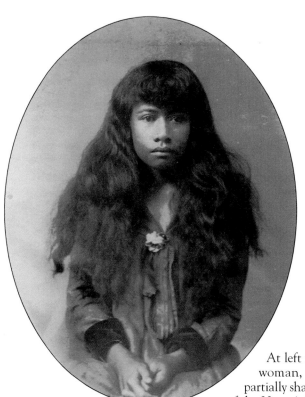

At left is a photograph of a young Hawaiian woman, and below is a young man with a partially shaved head and facial tattoos. (Courtesy of the Hawai'i State Archives.)

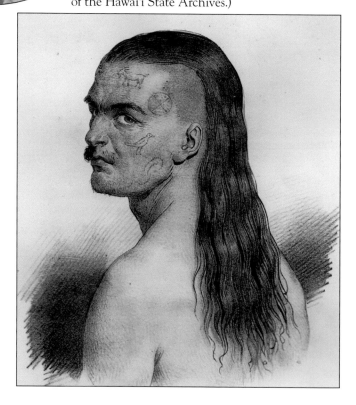

This is a translation of a land claim for a piece of property located at Pupukea on the North Shore. The Land Commission Applications sometimes resulted in an award, and sometimes not. (Courtesy of the Hawai'i State Archives.)

No. 7422    Kaawa         Pupukea, Oahu, January 22, 1848      Page 335

To the Land Commissioners:  I, Kaawa, an a claimant of land at Pupukea, in the mo'o of Kapuaa. There is also a fishery pertaining to it. It is bounded on the north by Kanae's land, on the east by Kaili- aloha's upland and Ehu's, on the south by Ehu's mo'o, on the west by the sea.
     The salt land is in the mo'o of Poohina. Those are the claims which I occupy at Pupukea, from the ma-

                                                              Page 336

kuas, and on their deaths it was bequeathed to me at this time. When these rights were gotten, Kamehameha I was the ruler.  Farewell to you all.  I am, respectfully,
                                             KAAWA, X his mark

No. 7423    Ku      Pupukea, Oahu, January 22, 1848

To the Land Commissioners:  I am a claimant at Pupukea, in the mo'o of Puulu. It is bounded on the north by Malamanui's land, on the east by Kaiwi's land, on the south by Kaiwi's also, on the west by the sea.
     A claim in another place is for one pali in the land of Poohina.
     The house lot is in the mo'o of Pohakahi. One sweet potato patch is there. One salt land is in the mo'o of Poohina.
     That is my claim at Pupukea by right of cultivation.  Farewell to you all.
                                             KU X his mark

No. 7424    Kawiwi      Waialua, January 5, 1848

To the Land Commissioners:  I, Kawiwi, hereby state my claims. I am a native born old timer here in Kawailoa, Waialua, and have had this claim for four years or more and no one has disputed it until this time.  The first is at Kupalu, Kawailoa, with ten lo'i, which adjoin the land of Kealohaio.  The second is at Hiwa, Kawailoa kai, three lo'i, which adjoin the lo'is of Iaea ma, and I also have a pali wauke together with it.  Third.  In the combined lot at Ukoa, one mala of gourd, which adjoins
                                                              Page 337

Kahakai ma's, and I also have a mala of sweet potato in this lot, adjoining Iaea ma's, and the wall, and the road.  Fourth.  I have a claim to take fish in Ukoa /Pond/.  Fifth.  My house lot, which is completely fenced.  Sixth.  Keae, Kawailoa waena, a pali wauke, which is next to the mala ko'ele.  Seventh.  We also have a right to pasture our animals.  Those are my claims.  I desire an award document.
                                             KAWIWI X his mark

Kupopolo Heiau was located near Waimea Bay. The heiau was a temple in the traditional system, and some were dedicated to the gods or war and others to more gentle deities. (Courtesy of the Hawai'i State Archives.)

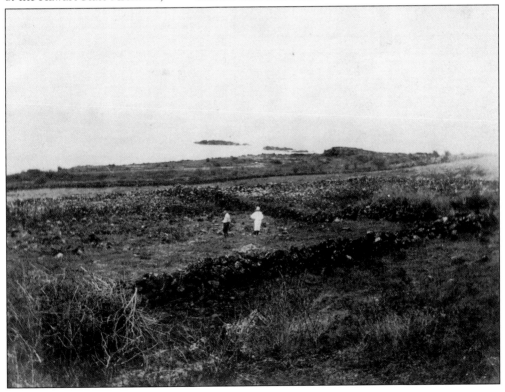

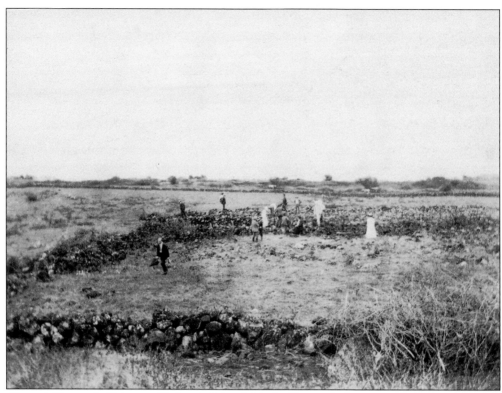

Above is Kupopolo Heiau, and below is Pu'u o Mahuka Heiau, the largest on the island of O'ahu. Both were of the luakini, or *po'okanaka* type, which were dedicated to the god Ku and the site of human sacrifices. (Above, courtesy of the Hawai'i State Archives, below, author's collection.)

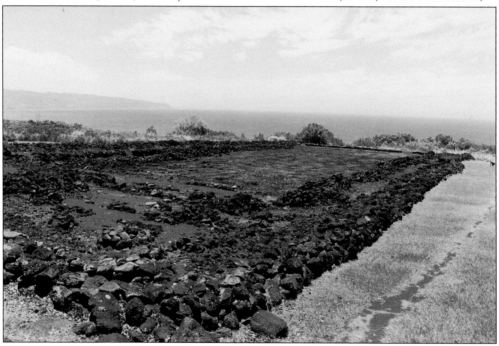

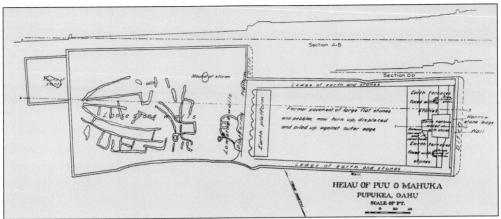

This archaeological map of Puʻu o Mahuka was rendered in the mid-20th century. Recent reconstruction and restoration efforts would result in the depiction of a much more complex structure if done today. (Courtesy of the Hawaiʻi State Parks.)

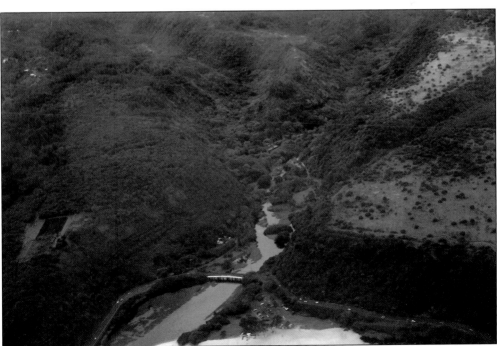

An aerial view shows Puʻu o Makuka (left) as it sits above Waimea Valley on the North Shore. (Courtesy of Maila Leinau.)

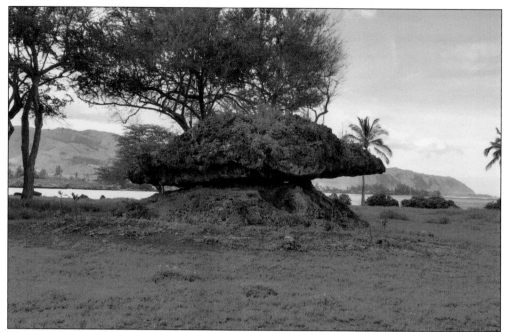

Pohaku o Lana'i is a coral formation said to have floated to the North Shore from Tahiti. This large feature was said to be a *marae*, or heiau, dedicated to a god named Tani. It is located in Waialua near the site of the now destroyed but important wooden heiau Kapukapuakea at a bay called "shadowed sea." (Author's collection.)

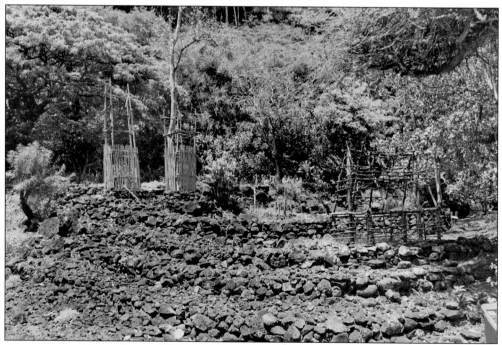

A reconstructed heiau deep in Waimea Valley is named Hale o Lono. It was discovered after being buried for perhaps 100 years and brought back to life by archaeologist Rudy Mitchell. Hale o Lono was dedicated to the god Lono, who was the overseer of crops and planting. (Author's collection.)

These carved wooden images of traditional Hawaiian gods were discovered some time ago in caves on the side of Waimea Valley. (Courtesy of the Hawai'i State Archives.)

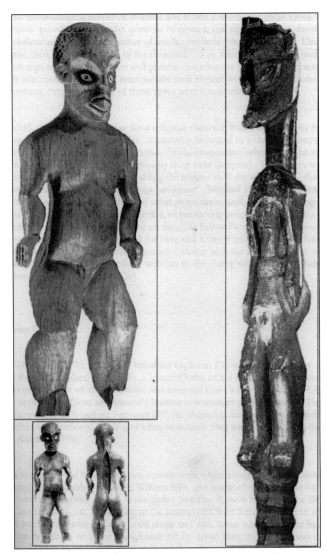

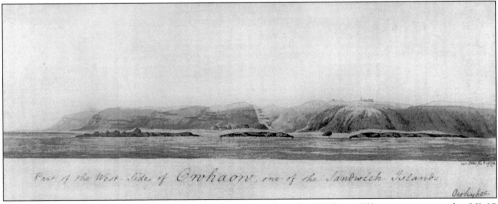

The first Western drawing of the North Shore was done by William Ellis, surgeon on the HMS *Discovery*, on February 2, 1779. (Courtesy of the Hawai'i State Archives.)

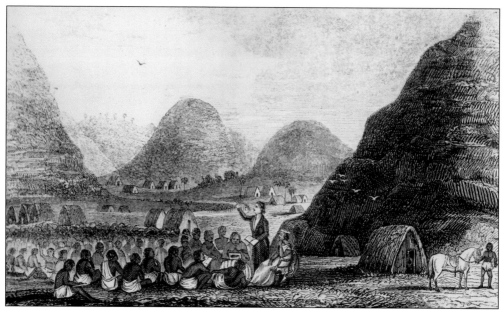

The missionary Hiram Bingham preaches to Queen Kaʻahumanu and others at Waimea Valley in 1826. In 50 short years after this drawing was made, Hawaiians had lost control of the valley's ownership, and it was not until 2009 that ownership returned to the Hawaiian people, when the valley was acquired by the Office of Hawaiian Affairs. (Courtesy of the Hawaiʻi State Archives.)

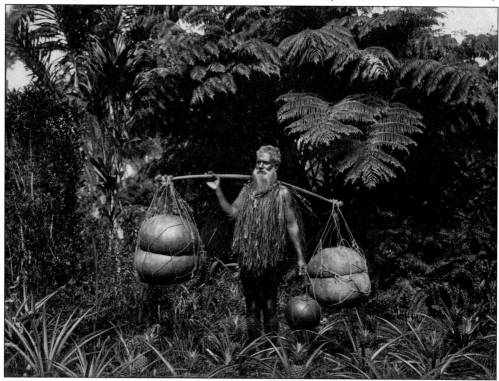

A Hawaiian man, wearing a traditional raincoat, carries his large gourd containers through a fern forest. (Courtesy of the Hawaiʻi State Archives.)

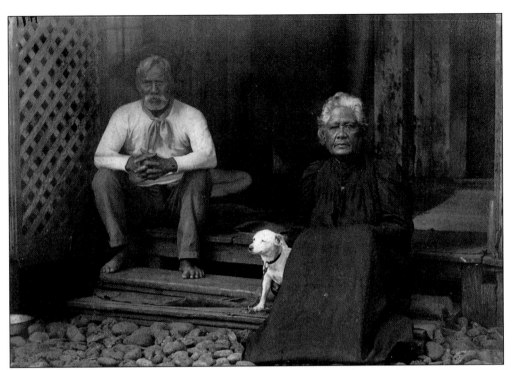

An unidentified Hawaiian couple and their dog are on the steps of their home. This photograph was most likely taken in the late 1800s. (Courtesy of the Hawai'i State Archives.)

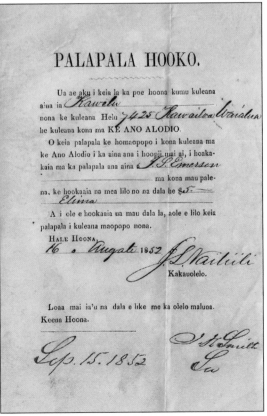

This photograph is of an original land grant document from 1852 during what is known as the Great Mahele, or division. This was the name given to the time period when property in Hawai'i was transformed into the Western system of ownership. (Courtesy of the Hawai'i State Archives.)

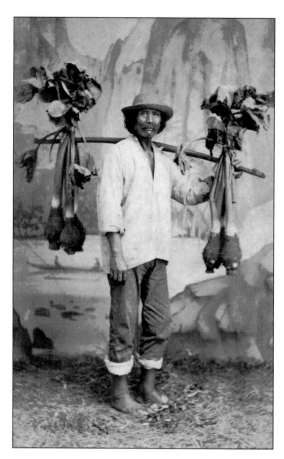

Hawaiian men display the traditional means of transporting items. At left are two bunches of taro corms and their leaves on either end of the pole, and below are calabashes probably holding poi, the mashed taro root and sustaining food of the Hawaiian people. (Courtesy of the Hawai'i State Archives.)

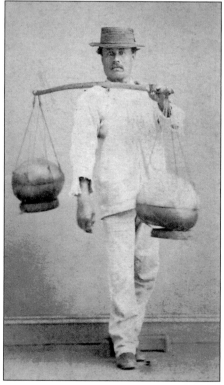

Hawaiians were quick to adapt to the Western system in many ways. After the introduction of cattle by Captain Vancouver in the late 1700s, new crops were planted to accommodate them. This particular gentleman was a purveyor of hay. (Courtesy of the Hawai'i State Archives.)

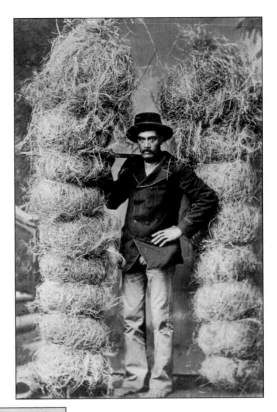

This photograph is of a page of original survey notes written by an unidentified white man in the Hawaiian language and dated from the time of the Great Mahele. (Courtesy of the Hawai'i State Archives.)

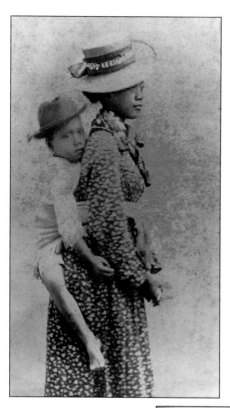

An unidentified Hawaiian mother carries her son in the 1800s. The Western clothing and Asian method of carrying the boy are indicative of the transformations and amalgamations that were taking place in the 19th century, as Hawai'i was rapidly becoming a cosmopolitan place. (Courtesy of the Hawai'i State Archives.)

This is an English-language translation of a Land Commission Application made by Hawaiians for a property at Pupukea on the North Shore during the Great Mahele. (Courtesy of the Hawai'i State Archives.)

```
No. 7420   Kaiwi       Pupukea, Oahu, January 22, 1848

To the Land Commissioners:  I, Kaiwi, am a claimant at Pupukea in
the mo'o of Kapu.  It is bounded on the north by Ku's land, on the
east by Kauwela's land, on the south by Kauwela's land, on the west
by the sea.
     Here are the claims in other places:  one patch in the mo'o of
Malamanui, one salt land in the mo'o of Poohina.  Those are the claim
in Pupukea.  The house lot is in the mo'o of Kauila.
     Here are the claims at Waimea:  three lo'i are in the land of
Malama, and a pali wauke.  Four lo'i are in the land of Keliiwaiwai-
ole.  One lo'i is in the land of Wahineoni.  They are surrounded by
their claims.
     Those are my little claims, from the makuas, who died.  They
have been bequeathed to me at this time.  They were acquired at the
time when Kamehameha I was the ruler.  Farewell to you all.

                                           KAIWI X his mark
```

```
No. 7421   Kalainaina    Pupukea, January 29, 1848

To the Land Commissioners:
                                           Page 335

I, Kalainaina am a claimant of land at Pupukea, and a house lot.
The land is bounded on the north by Kailialoha's, on the east by a
pali and the kula, on the south by Kanae's land, on the west by a
government pa'ahao patch and the road.
     The house lot is bounded on the north by a stream, on the east
by a pali, and on the south by pali also, on the west by the road and
Hoona's house lot.  Two steep sweet potato plantings are surrounded
by Kaawa's claim.  One sweet potato patch adjoining the seashore is
bounded on the north by Kanae's land, on the east by the road, on the
south by Kamalio's land, on the west by the seashore.  All these
claims of mine are in the mo'o of Kaawa.
     Here are my claims in other places:  in the mo'o of Ehu, two
mala of noni, surrounded by Ehu's claim on all sides.  Also, there
is a salt land in Poohina's land.  That is the claim at Pupukea.
     Also, there is a claim at Waimea for two lo'i in the mo'o of
Malama and one pali wauke, surrounded by Malama's land.  Those are
my claims, from the makuas, which were gotten when Kamehameha I was
the ruler.  Farewell to you all.
                                      KALAINAINA X his mark
```

An unidentified Hawaiian woman poses for a formal studio portrait in the late 1800s. (Courtesy of the Hawai'i State Archives.)

An unidentified Hawaiian gentleman pounds taro corms into poi using a traditional hand-formed basalt rock. Poi, sweet potato, and breadfruit were the carbohydrate staples in Hawai'i for centuries; however, poi was the preferred food, is almost uniquely Hawaiian, and is recognized by health experts as a nearly perfect food. (Courtesy of the Hawai'i State Archives.)

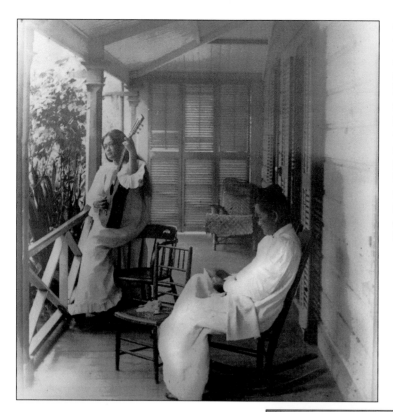

Two unidentified Hawaiian women enjoy an afternoon on the front porch, or *lanai*. Always lovers of song, dance, and music, the Hawaiians very quickly became experts in mastering many Western instruments, but they were especially fond of the guitar. (Courtesy of the Hawai'i State Archives.)

A photograph of an original North Shore land application includes a sketch map of the subject property at the bottom of the document. (Courtesy of the Hawai'i State Archives.)

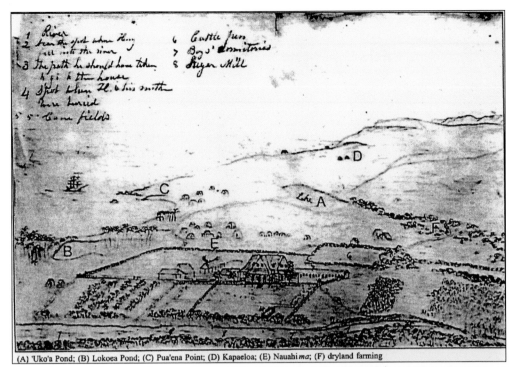

An early pencil drawing of the North Shore shows a sailing ship offshore as well as farm plots. (Courtesy of the Hawai'i State Archives.)

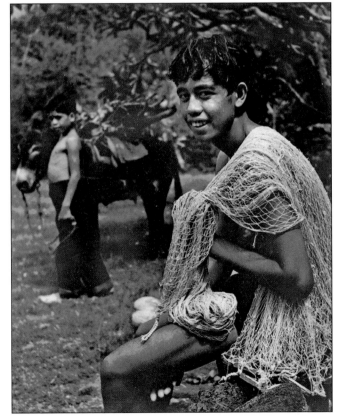

An unidentified young man is depicted with a traditional "throw net" over his shoulder as he prepares for a close-to-shore fishing trip. (Courtesy of the Hawai'i State Archives.)

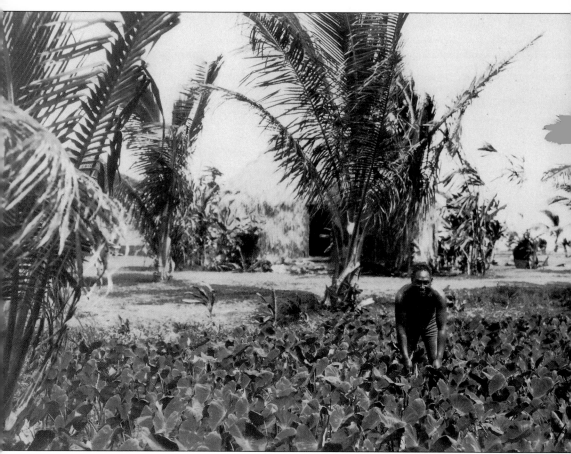

An unidentified Hawaiian man tends to his taro patch. There were two types of taro: that grown in *lo'i*, or flooded ponds, and dryland taro that was planted much like a potato. Both types were grown extensively on the North Shore. This gentleman is in his lo'i. (Courtesy of the Hawai'i State Archives.)

# Two

# A Tidal Wave
# of Change
## The North Shore Melting Pot

The North Shore was at its precontact peak in the 1790s, but just 50 short years later the founder population had lost control of a substantial portion of its land, was decimated by imported disease, and saw its principal crops replaced. What was left of the Hawaiian populace was attempting to adjust to a new belief system. On the way to this sad situation, and partially causing it, was that in the 1820s Waimea Valley was stripped of nearly every stick of its rich sandalwood holdings, and shortly after foreign missionaries began erecting churches to an unfamiliar god. The first Christian church on the North Shore was established in 1832 by American missionaries John and Ursula Emerson in Waialua and was located about in the center of what is now known as the town of Haleʻiwa.

In the early 1850s, two massive changes came to the North Shore. The first was called the Great Mahele, which changed the land tenure system in the islands from a traditional chiefly arrangement to one based on private ownership. In the process, it has been estimated that only three percent of the founder population ended up owning any land. The second massive change that occurred in the early 1850s came in the form of pineapple and sugarcane production. With huge tracts of land now in the hands of foreign businessmen, large plantations were established on prime agricultural lands, and the North Shore quickly became a target location. With the Hawaiian population now at about one-sixteenth of its original strength and because those who were left had little enthusiasm for plantation life, there was a need for an imported labor force. Over the next 50 years, more than 7,500 Koreans laborers came to Hawaiʻi in addition to 20,000 Portuguese, 50,000 Chinese, 112,800 Filipinos, and 200,000 Japanese. A relatively significant percentage of these people settled in plantation camps on the North Shore and would change the character of the country forever.

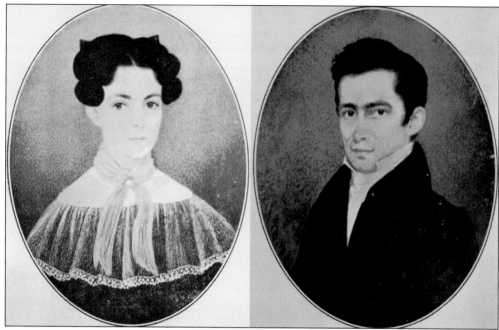

The new wave essentially began with the introduction of a new religion. Rev. John Smith Emerson of Chester, New Hampshire, was born in 1800 and was a graduate of Dartmouth College and Andover Theological Seminary. He married Ursula Sophia Newell in 1831 after serving for the American Board of Commissioners for Foreign Missions. The Emersons traveled on the New Bedford whaling ship *Averick* and arrived in Honolulu on May 17, 1832; their group was known as the Fifth Company of American Missionaries. Shortly after their arrival, they founded the Congregational Church at Hale'iwa, Waialua. (Courtesy of the Hawaiian Mission Children's Society.)

This was the Emerson's first home on the North Shore, located near the present site of Emerson Road in Hale'iwa. They raised eight children here. (Courtesy of the Hawaiian Mission Children's Society.)

Queen Liliʻuokalani Church was founded in 1832. The first church was a grass house on the corner of Kamehameha Highway and Haleiwa Road that was reported to be able to hold up to 2,000 people. The second church (pictured here) was built in 1840. (Courtesy of the Hawaiian Mission Children's Society.)

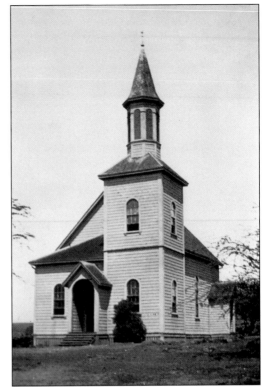

The church is named after Queen Liliʻuokalani, who worshiped here. Liliʻuokalani ascended the throne in 1891 after the death of her brother King Kalakaua and was the last reigning monarch of Hawaiʻi. (Courtesy of the Hawaiian Mission Children's Society.)

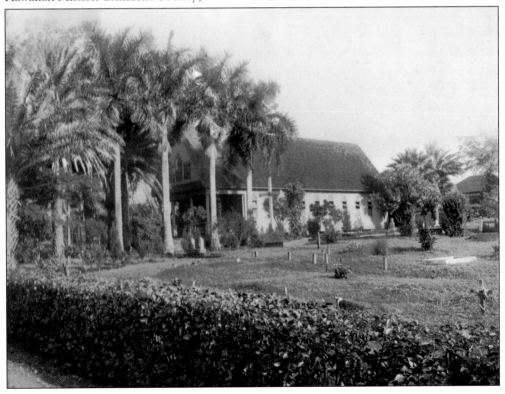

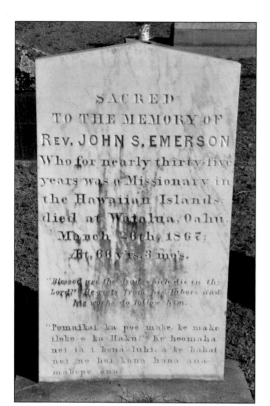

This is a photograph of the grave of John Emerson, located in the cemetery next to his church. (Author's collection.)

SACRED
TO THE MEMORY OF
REV. JOHN S. EMERSON
Who for nearly thirty-five
years was a Missionary in
the Hawaiian Islands,
died at Waialua, Oahu,
March 26th, 1867;
Æt. 66 yrs. 3 mo's.

"Blessed are the dead which die in the Lord." "He rests from his labors and his works do follow him."

"Pomaikai ka poe make, ke make iloko o ka Haku." ke heomaha nei ia i kona luhi, a ke hahai nei no hoi kona hana ana mahope ona:

Sacred
to the Memory of
URSULA SOPHIA NEWELL
Wife of
REV. JOHN S. EMERSON
Born at Nelson N.H. U.S.A.
Sept. 27, 1806.
Died Nov. 24, 1888
at Waialua Oahu
the scene of her labors
for over half a century.

For the things which are seen are temporal, but the things which are not seen are eternal.

Next to the grave of Reverend Emerson in the church graveyard is that of his wife, Ursula, who lived to be 88 years old. (Author's collection.)

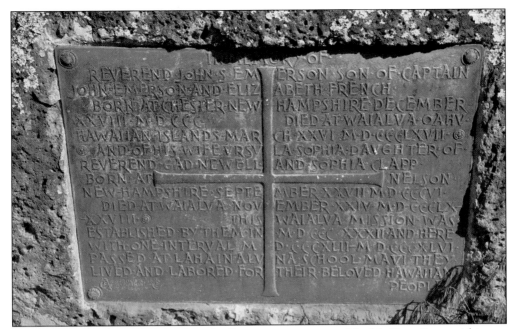

An appreciative plaque dedicated to the Emersons was prepared by his Hawaiian parishioners and affixed to a large boulder in the churchyard near the graves of the reverend and his wife. (Author's collection.)

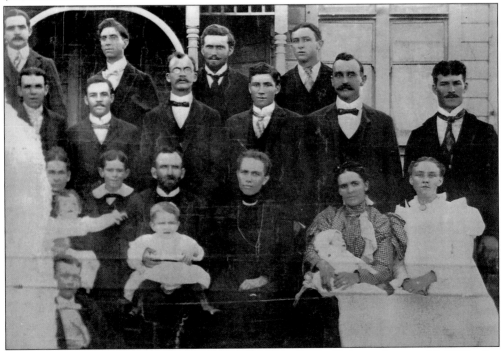

A group of early Mormon missionaries settled in the village of Lāʻie on January 26, 1865, after the church purchased a 6,000-acre plantation for $14,000, and immediately began to care for the temporal welfare of church members. (Courtesy of the Brigham Young University–Hawaii photographic collection.)

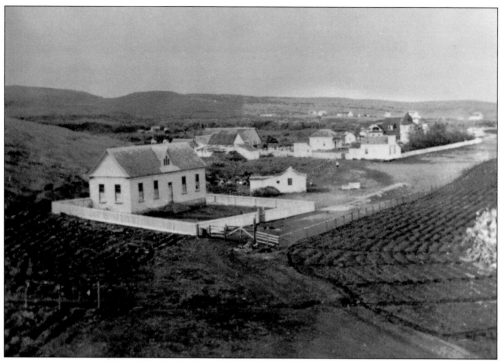

An early Mormon compound was located in La'ie. (Courtesy of the Brigham Young University–Hawai'i collection.)

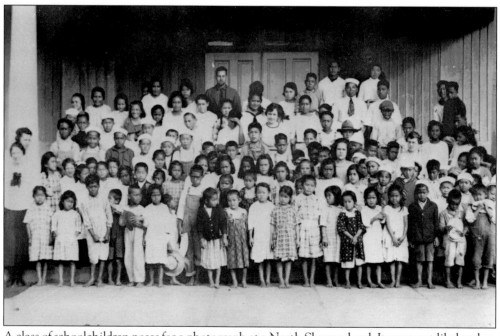

A class of schoolchildren poses for a photograph at a North Shore school. It was most likely taken at the close of the 19th century. Missionaries of all denominations made education of the local population one of their main focuses when they reached Hawai'i. (Courtesy of the Brigham Young University–Hawaii photographic collection.)

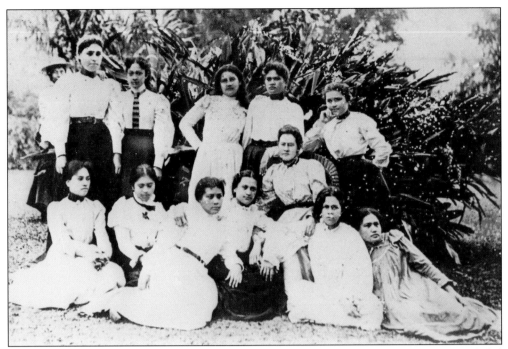

This photograph is entitled "Young Mormon Mothers," and by the late 1800s the group included woman of many nationalities and reflected Hawai'i's growing cosmopolitan population. (Courtesy of the Brigham Young University–Hawaii photographic collection.)

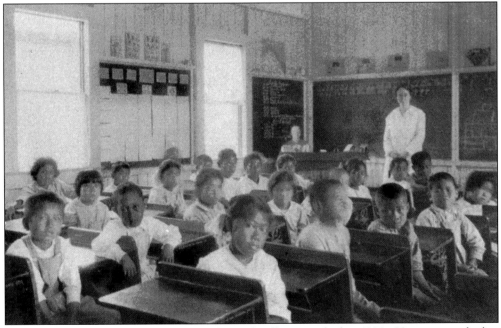

Local children have gathered in a North Shore schoolhouse in the late 1800s. Hawaiians and other island children developed an early love for reading and writing. By the end of the 19th century, Hawai'i was perhaps, per capita, the most literate place on Earth. (Courtesy of the Brigham Young University–Hawaii photographic collection.)

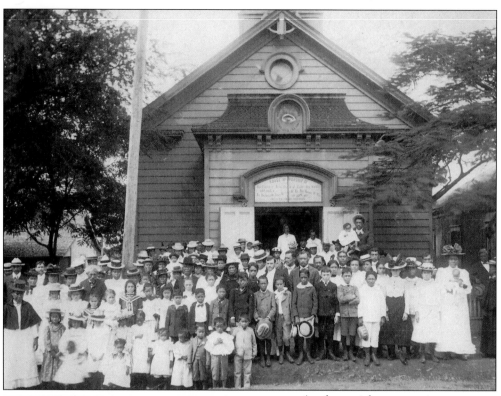

A substantial congregation poses in front of a North Shore church. In addition to embracing reading and writing, Hawaiians flocked to Christian churches, which became the focal point for their communities. (Courtesy of the Brigham Young University–Hawaii photographic collection.)

Hawaiians also embraced intermarriage, and by the turn of the 20th century there were many mixed-race families. Unions between Hawaiians, Chinese, and Americans were quite common. (Courtesy of the Brigham Young University–Hawaii photographic collection.)

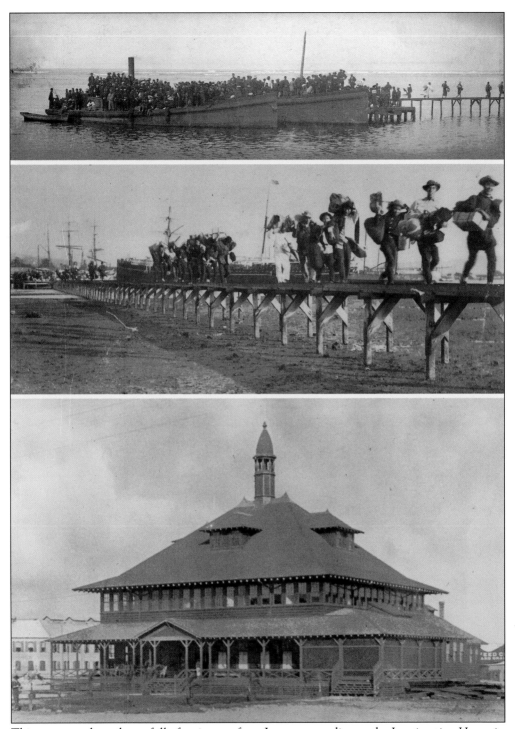

This montage shows boats full of emigrants from Japan proceeding to the Immigration House in Honolulu before heading out to the plantations. (Courtesy of the Hawai'i State Archives.)

These are the original immigration papers that were needed in order to leave Japan and ones that were needed in order to enter the Kingdom of Hawai'i. (Courtesy of the Matsumoto family.)

Once settled in Hawai'i, much of the Japanese population married and thus began that group's long and successful history as citizens of Hawai'i. (Courtesy of the Matsumoto family.)

A large number of unidentified Japanese plantation workers pose in the middle of their camp homes. The camps were initially segregated by ethnicity. (Courtesy of the Hawai'i State Archives.)

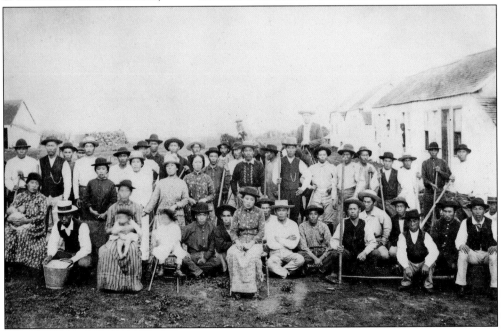

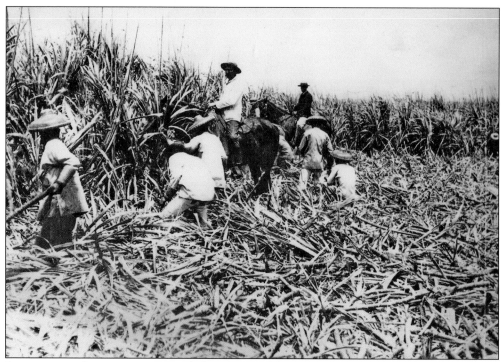

Immigrant workers cut sugarcane while a mounted *luna*, or supervisor, oversees the operation. (Courtesy of the Hawai'i State Archives.)

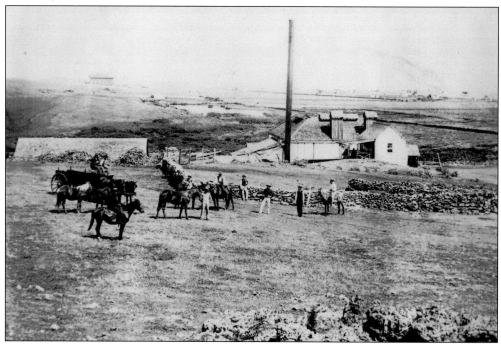

An early sugarcane mill in La'ie later developed into a sugar mill, a large temple, a university, and an extensive, multiethnic country community. (Courtesy of the Brigham Young University–Hawaii photographic collection.)

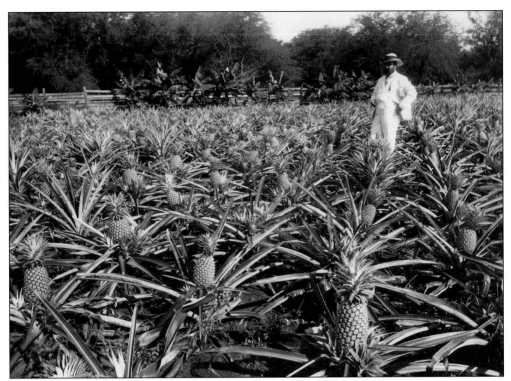

An unidentified plantation owner inspects his pineapple plantings. Pineapple plantations in Hawai'i were created from bromeliad cuttings obtained, under questionable circumstances, from Central America. (Courtesy of the Hawai'i State Archives.)

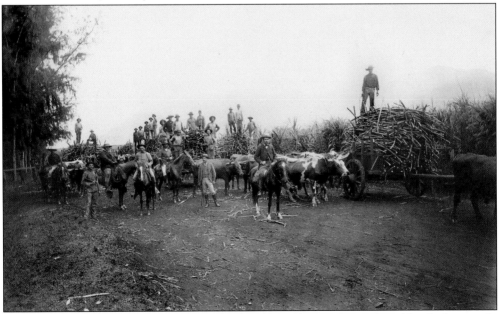

Oxen haul carts of cut sugarcane to the mill. The effort to bring sugar to the table relied primarily on human effort, which was then augmented by beasts and, finally, partial mechanization. (Courtesy of the Hawai'i State Archives.)

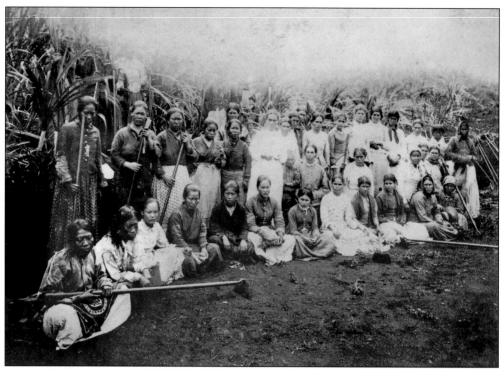

This photograph of a group of plantation workers was taken in the late 1800s. It demonstrates that at least five different ethnic groups were involved in the primary effort. (Courtesy of the Hawai'i State Archives.)

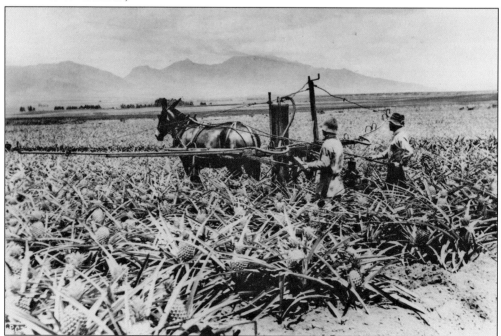

In the early days, horsepower as well as oxen were used on both sugarcane and pineapple plantations. (Courtesy of the Hawai'i State Archives.)

An unidentified Filipino man wields the distinctive cane knife that would be a signature and essential component of all field labor in Hawai'i until the 1990s. (Courtesy of the Hawai'i State Archives.)

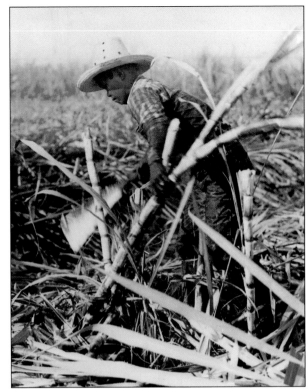

Once the raw product was cut, washed, and separated, workers packed cut pineapple in the fields. (Courtesy of the Hawai'i State Archives.)

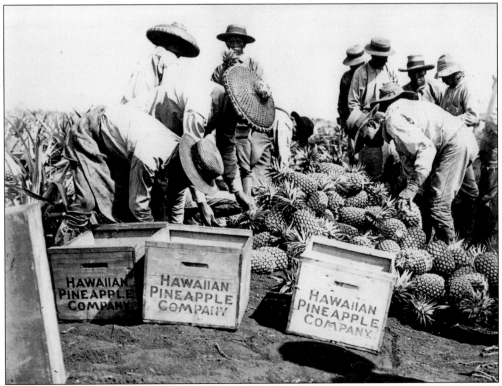

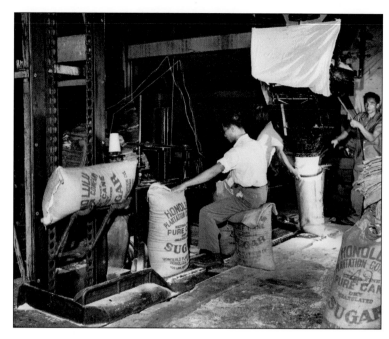

The sugar process was more elaborate, in some ways, than pineapple production. Cut and processed sugarcane was taken to North Shore mills for shipment to various locations abroad. A sign in Waialua still proclaims that it is the home of "The finest Sugar in the World." (Courtesy of the Hawai'i State Archives.)

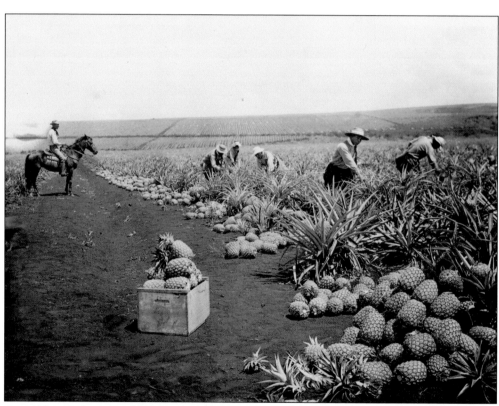

An unidentified, mounted luna supervises the cutting and stacking of pineapple. In the beginning, luna were mostly white, but this changed over time. (Courtesy of the Hawai'i State Archives.)

A group of unidentified Mormon workers poses before a Victorian house in La'ie. (Courtesy of the Brigham Young University–Hawaii photographic collection.)

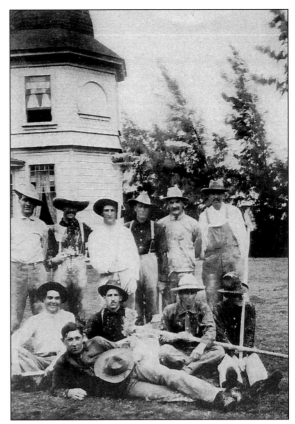

An unidentified Japanese woman crates freshly cut pineapple in the field. (Courtesy of the Hawai'i State Archives.)

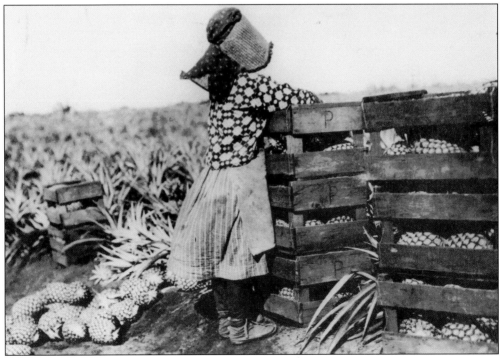

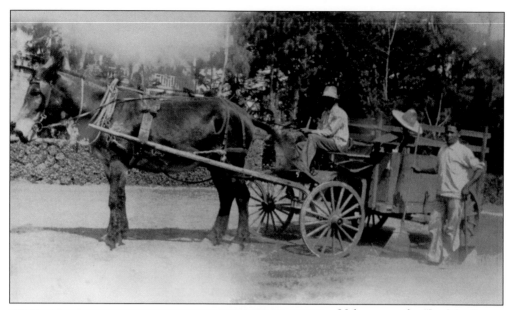

Uehara was the "Ice Man" for a number of North Shore communities. He is pictured here with his delivery wagon. (Courtesy of the Brigham Young University–Hawaii photographic collection.)

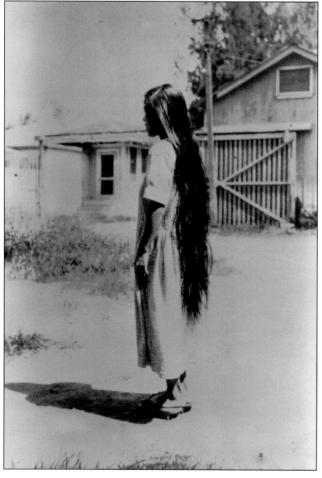

In this photograph of Uehara's wife, her exceptionally long and beautiful hair is, and remains, a signature of the Japanese Hawaiian community. (Courtesy of the Brigham Young University–Hawaii photographic collection.)

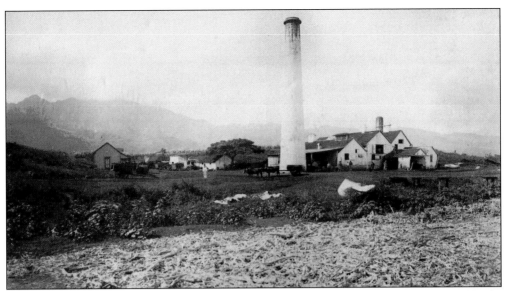

This is most likely a photograph of the Halstead Sugar Mill in Waialua. It was previously owned by the Reverend Emerson and later became the Waialua Mill. (Courtesy of the Hawai'i State Archives.)

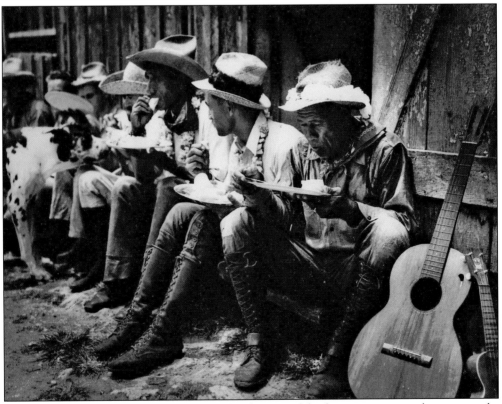

The Hawaiian people did not care much for the plantation life of cutting cane or picking pineapple; this does not mean, however, they were not a vibrant part of the North Shore changes at this time. Early on, Hawaiians were keen to become cowboys, or paniolo, on the various ranches located on the North Shore. (Courtesy of the National Archives.)

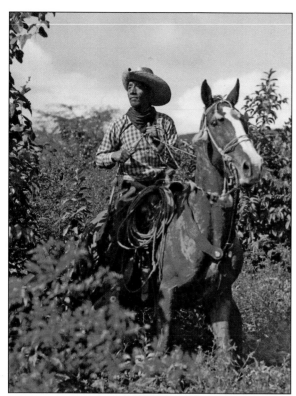

The Hawaiian paniolo absolutely excelled at his craft and was a skilled horseman so adept at all-around ranching activities that this group won many rodeo competitions in Wyoming and other Western states. (Courtesy of the National Archives.)

Benjamin Dillingham arrived in Honolulu as a sailor in 1865 and soon recognized the need for a railroad system for O'ahu and the plantations. He obtained a government railroad charter from King David Kalakaua on December 11, 1888. (Courtesy of the Hawai'i State Archives.)

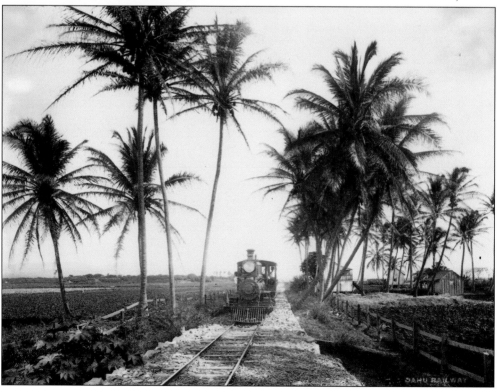

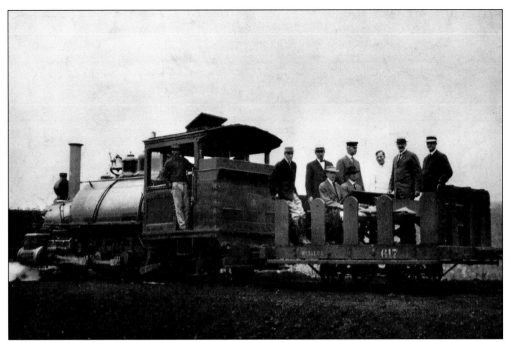

In January 1897, the company began extending the railroad around Oʻahu's rugged Kaʻena Point and reached Haleʻiwa on the North Shore by June 1897. By December 1898, the main line was complete, stretching to Waimea Bay and past Sunset Beach on the way to the Kahuku sugar mill. (Courtesy of the Hawaiʻi State Archives.)

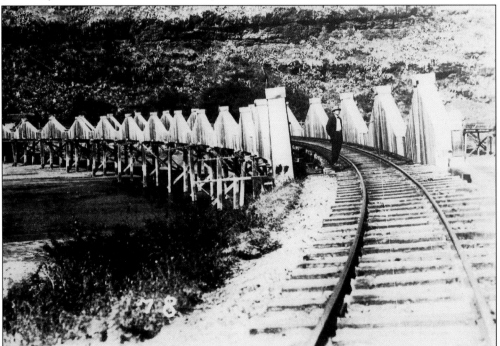

This image shows Dillingham's railroad tracks and bridge across the stream at Waimea Bay. (Courtesy of the Hawaiʻi State Archives.)

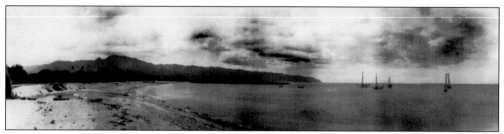

Hale'iwa Harbor is pictured at the dawn of the Dillingham era. (Courtesy of the Hawai'i State Archives.)

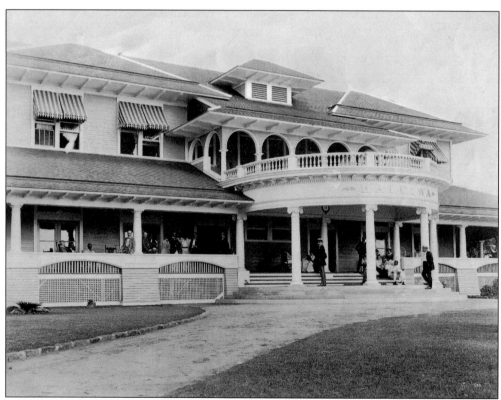

With the success of the railroad, many people from Honolulu discovered the beauty of the North Shore, and the enterprising Dillingham thought that he would build a beautiful hotel to accommodate overnight and holiday visitors. This would result in the construction of the Hale'iwa Hotel in 1899, the first of its kind on the North Shore. (Courtesy of the Hawai'i State Archives.)

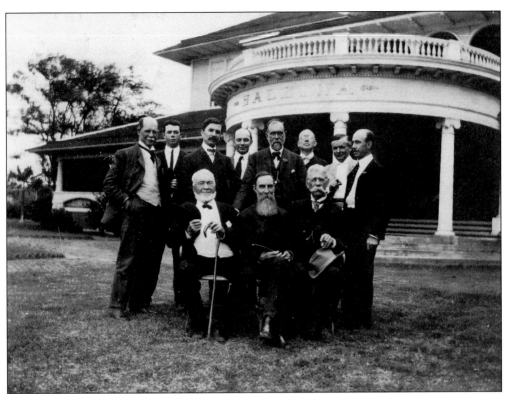

A group called the Kupopolo Preservation Society poses in front of the Haleʻiwa Hotel in 1905. Apparently, one of the many positive results of the hotel was an awareness of preserving the historical sites on the North Shore. Curiously, the hotel itself was built on the ruins of Kamani Heiau. (Courtesy of the Hawaiʻi State Archives.)

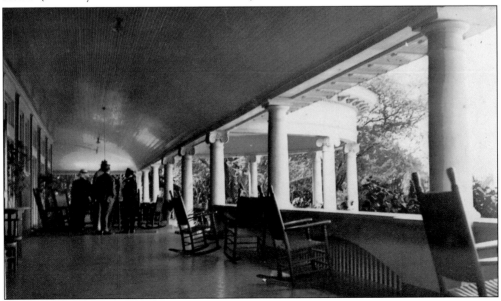

The Grand Lanai at the Haleʻiwa Hotel was the location of afternoon tea and cocktails. (Courtesy of the Hawaiʻi State Archives.)

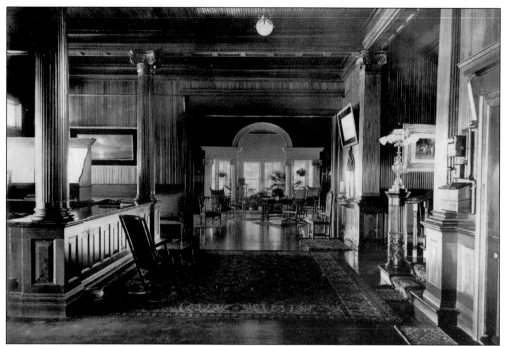

Dillingham hired the renowned mainland architect Oliver Green Traphagen to build this magnificent two-story Victorian structure and appointed the building with electric lights from the hotel's own generator, telephones, interiors paneled with fine koa wood, and many other trappings never before seen on the North Shore. (Courtesy of Hawai'i State Archives.)

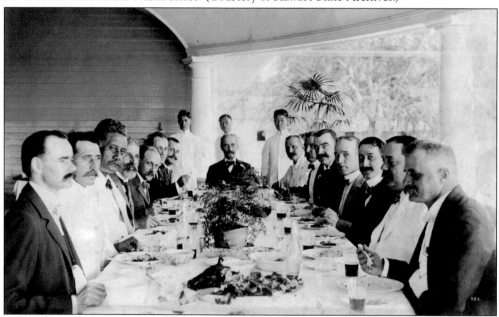

Room rates at the Hale'iwa Hotel were $3 a day and the round-trip fare from Honolulu on Dillingham's train was $2. The manager said, "We buy our fish alive at the beach, raise our own vegetables, fruit, chickens, and eggs, and get our meat and milk from a nearby ranch." (Courtesy of the Hawai'i State Archives.)

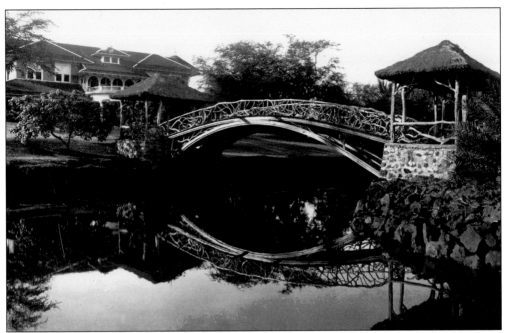

The rustic bridge across the Anahulu River connected the hotel to the train station. (Courtesy of the Hawai'i State Archives.)

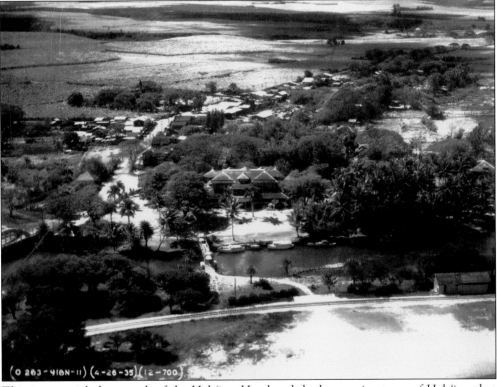

This is an aerial photograph of the Hale'iwa Hotel and the burgeoning town of Hale'iwa that grew up behind it. (Courtesy of the Hawai'i State Archives.)

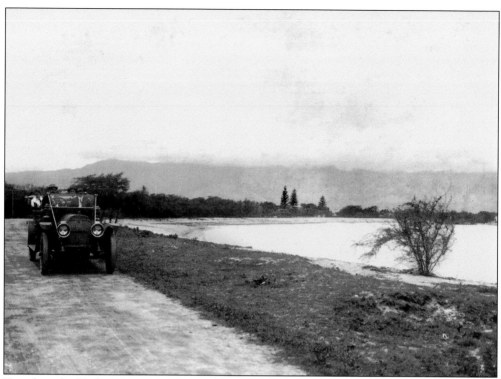

Kamehameha Highway is pictured around 1900 as it passes by where today's Hale'iwa Beach Park is located. (Courtesy of the Hawai'i State Archives.)

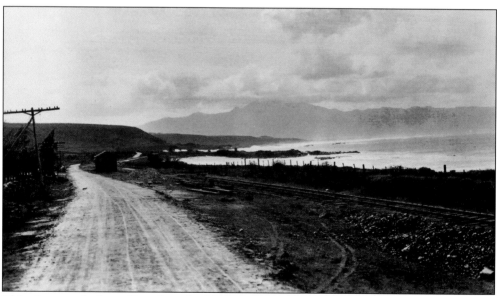

This photograph shows Kamehameha Highway with the railroad tracks on the seaward side. (Courtesy of the Hawai'i State Archives.)

A North Shore home has a flooded taro patch, or lo'i, behind it. (Courtesy of the Hawai'i State Archives.)

A photograph shows a group of multiethnic North Shore schoolchildren. It is interesting to note that the only barefoot member of the class was a *haole*, or Caucasian, student. (Courtesy of the Brigham Young University–Hawaii photographic collection.)

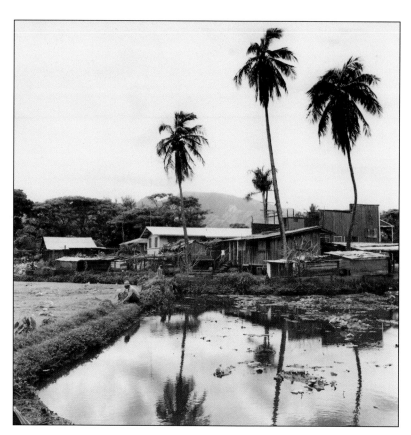

This home located in what is now downtown Hale'iwa has a flooded taro patch. (Courtesy of the Hawai'i State Archives.)

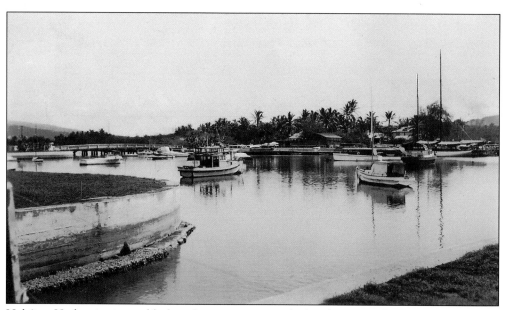

Hale'iwa Harbor is pictured before the construction of a breakwater and other improvements. (Courtesy of the Hawai'i State Archives.)

A photograph of the seal on the Sanborn Fire Insurance Map shows Waialua and Hale'iwa having a population of 1,200 people in March 1927. (Courtesy of the Hawai'i State Archives.)

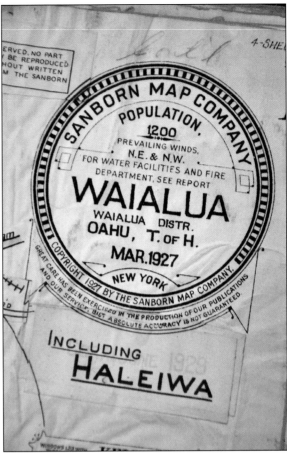

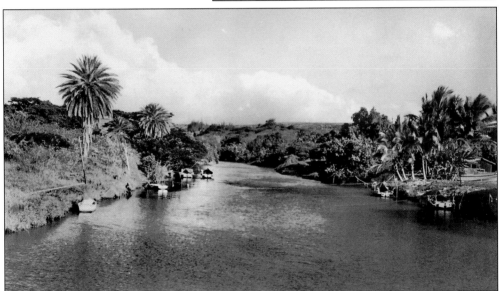

The Anahulu River passes through Hale'iwa. It is the longest river on the island of O'ahu. (Courtesy of the Hawai'i State Archives.)

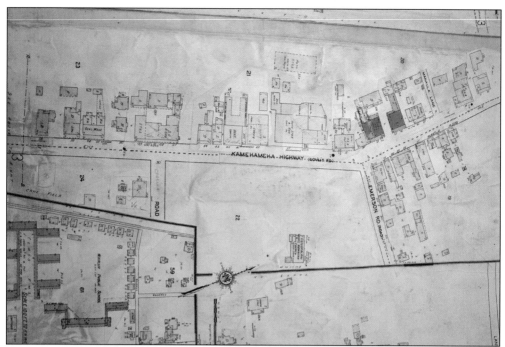

A portion of the business buildings in downtown Haleʻiwa is depicted in 1927. (Courtesy of the Hawaiʻi State Archives.)

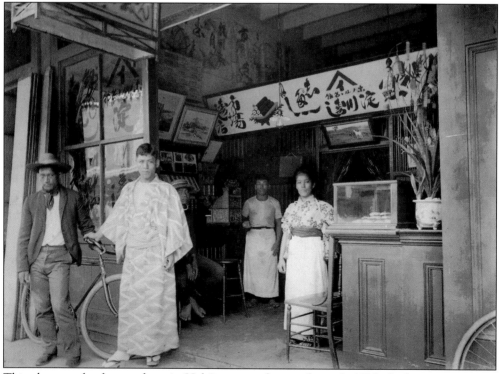

This photograph of a storefront in Haleʻiwa was taken in the early 1920s. It showcases a cross-section of both goods and customers. (Courtesy of the Hawaiʻi State Archives.)

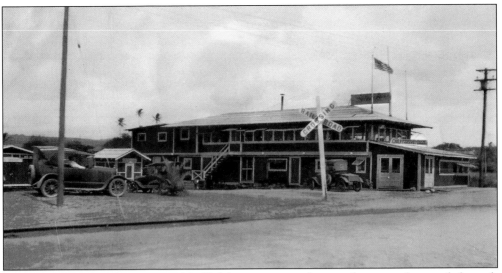

This Japanese-owned store in 1920s Hale'iwa was one of many that were financed through collective loans from other members of the Japanese community. (Courtesy of the US Army Tropic Lightning Museum.)

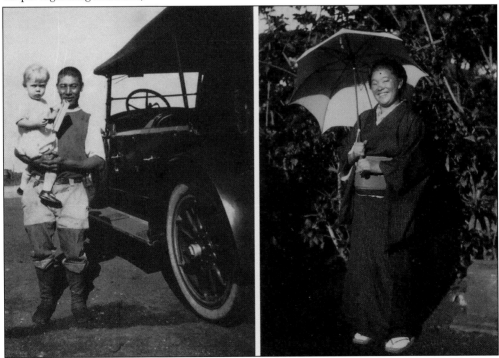

Mr. Kiyota is pictured here holding little Jeanne Derby in 1923, and next to them is Mr. Kiyota's wife. Both photographs were taken near the home of Dan and Waleska Derby in Pupukea. Kiyotasan worked for Dan, who was the superintendent on Libby's pineapple plantation. Kiyotasan would carry Jeanne on his shoulders down steep, unpaved Pupukea Road to Niimi Store to buy Nabisco cookies for her. Tragically, Kiyotasan drowned while picking the limpet known locally as *opihi* at Laniakea in 1934. After his death, the Derbys generously provided assistance in order to help Mrs. Kiyoto return to her family in Japan. (Courtesy of Barbara Ritchie.)

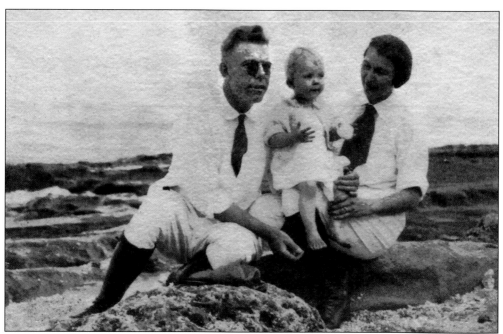

Dan Charles Derby came to Pupukea in 1917 to work for the Libby pineapple plantation. He is pictured here with his wife, Waleska Kerl, an elementary schoolteacher at Waialua School from 1918 until 1923. This photograph was taken with their daughter Jeanne near the Haleʻiwa Hotel. (Courtesy of Barbara Ritchie.)

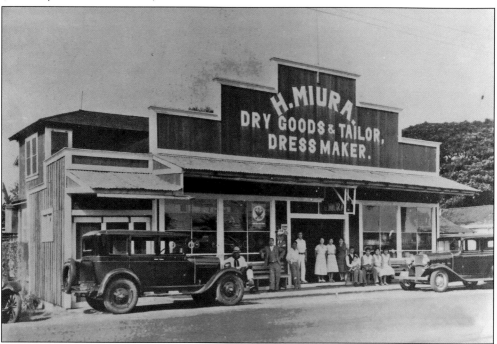

The original H. Miura Store is pictured; it burned down in 1918. The Miura family rebuilt and went on to make quality, custom clothing for North Shore residents for another 85 years. (Courtesy of the Miura family.)

This is one of the early Fujioka Stores in Waialua. Like the Miuras and other Japanese entrepreneurs, the Fujiokas provided goods and friendly services to North Shore residents for generations. (Courtesy of the Haleʻiwa Surf Museum.)

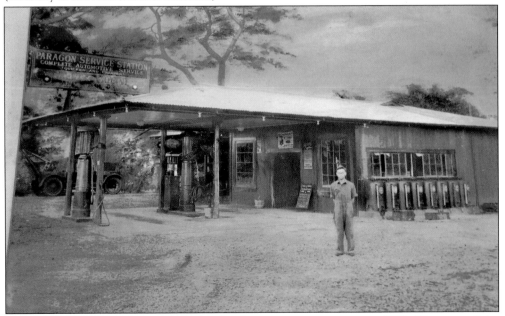

Shegiji Kawamata stands proudly before his Paragon service station in 1928. (Courtesy of the Kawamata family.)

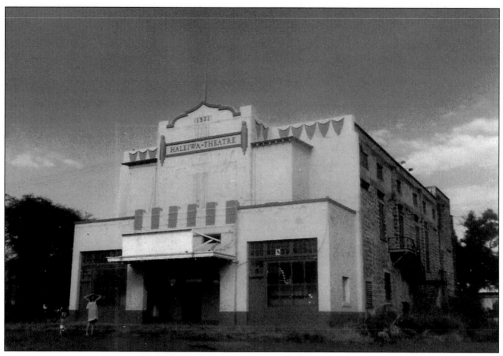

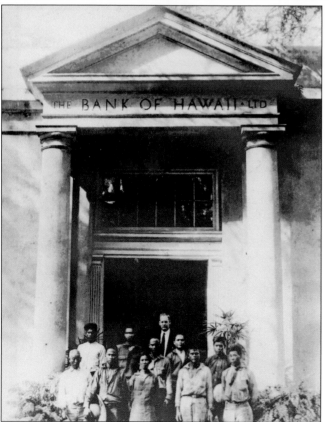

The Haleiwa Theater was built in Art Deco style by architect Hego Fuchino in 1931. In its time, it showed first-run Hollywood releases and, later, ethnic Japanese and Filipino shows, and, later still, surf films. In spite of a heroic effort by local preservationist Capt. Richard Rogers and others, it was unfortunately destroyed in 1983 and now a fast-food emporium stands at the spot. (Courtesy of the Matsumoto family.)

Employees stand before the Bank of Hawaii on opening day in Waialua. (Courtesy of the Wooley brothers.)

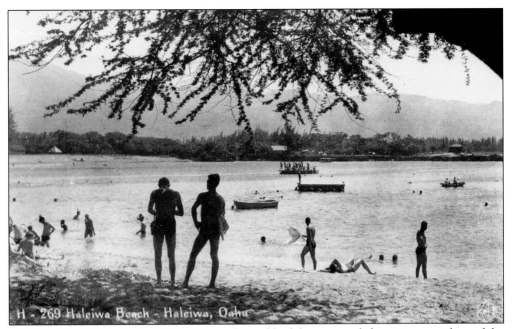

Haleʻiwa Beach Park in the 1940s was mostly used by fishermen and, for a time, members of the military. (Courtesy of the Hawaiʻi State Archives.)

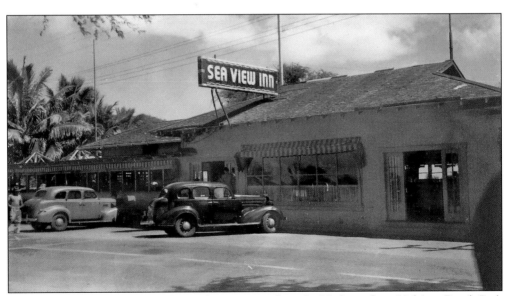

The original Sea View Inn was located across Kamehameha Highway from Haleʻiwa Beach Park and served local and American food to the community and what few tourists ventured to the North Shore. (Courtesy of the Matsumoto family.)

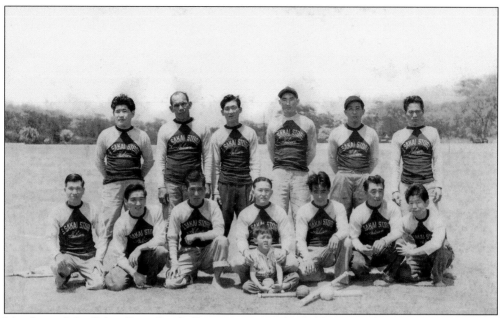

Members of the Sakai Store baseball team pose on the field in Waialua. North Shore teams usually competed against each other, and an occasional road trip to Waipahu or even Honolulu was considered a special event. (Courtesy of the Matsumoto family.)

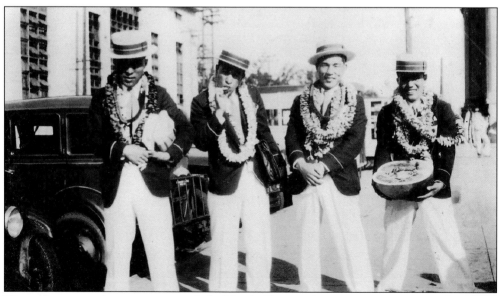

These dapper gentlemen represented the North Shore in boxing competitions in the 1930s. (Courtesy of the Matsumoto family.)

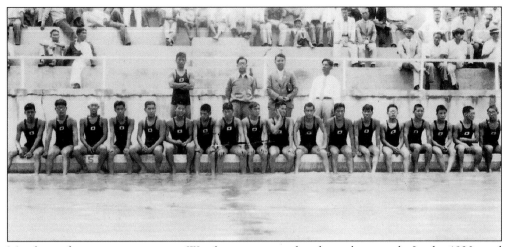

Members of a swimming team in Waialua group together for a photograph. In the 1920s and 1930s, sporting teams were organized along ethnic lines; it would be nearly impossible to imagine a swim team representing the whole North Shore with no Hawaiian boys present. (Courtesy of the Matsumoto family.)

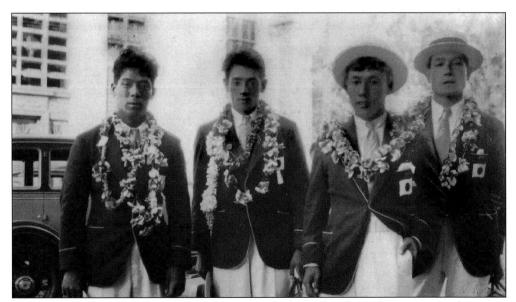

A diving team from Hale'iwa poses for the camera in the 1930s. The author is not exactly certain if there was a swimming pool on the North Shore at this time, and so it is possible these young men practiced their skills in saltwater. (Courtesy of the Matsumoto family.)

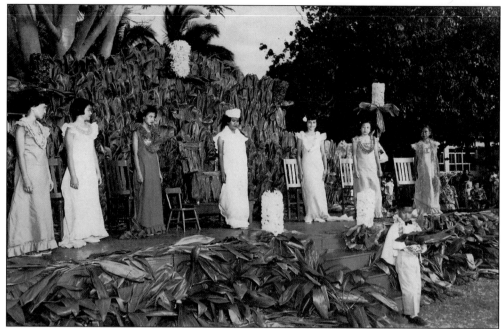

Young Japanese American women participate in a Hawaiian-style pageant. The stage is covered in *ti* leaves and there are Hawaiian leis and even a *kahili*, or staff, denoting Hawaiian royalty. This is a good demonstration of how Hawai'i becomes the defining agent no matter one's ethnicity or country of origin. (Courtesy of the Matsumoto family.)

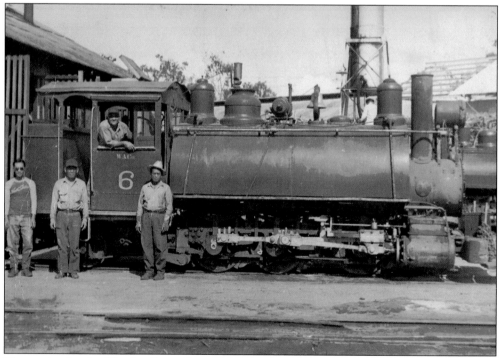

The engine for the Waialua Sugar Companies train and its attendants are pictured at the mill. (Courtesy of the Lunasco family.)

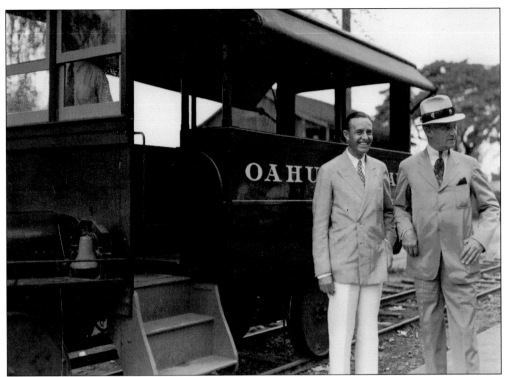

Secretary of Commerce William Averell Harriman (left) and Walter Dillingham are in front of the train line Dillingham promoted and created. (Courtesy of the Dailey/Dillingham family.)

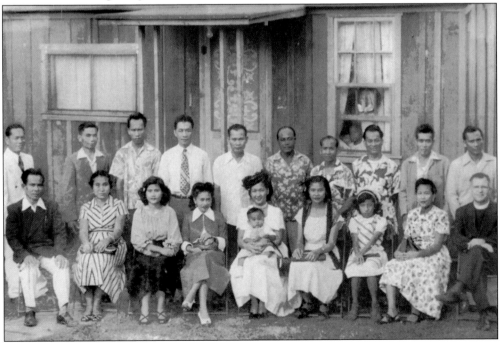

A Filipino extended family gathers in front of a camp home for a group photograph with their parish priest. No one is identified by name. (Courtesy of the Lunasco family.)

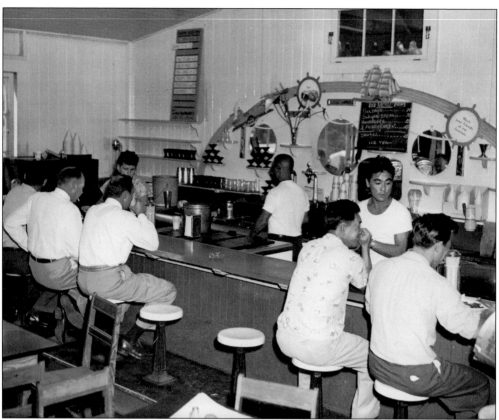

A North Shore eatery in the 1940s served foods that catered to the various ethnic groups living on the North Shore. (Courtesy of the Hawai'i State Archives.)

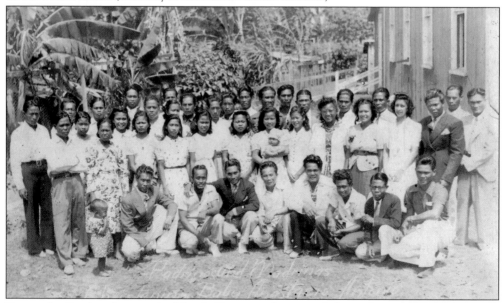

Strong family ties characterize North Shore residents, and the gathering of generations is commonplace to this day. (Courtesy of the Lunasco family.)

Proprietors of the S. Tanaka Store in Kahuku stand in front of their establishment. They represent the third generation of ownership and service at this location. (Courtesy of the Brigham Young University–Hawaii photographic collection.)

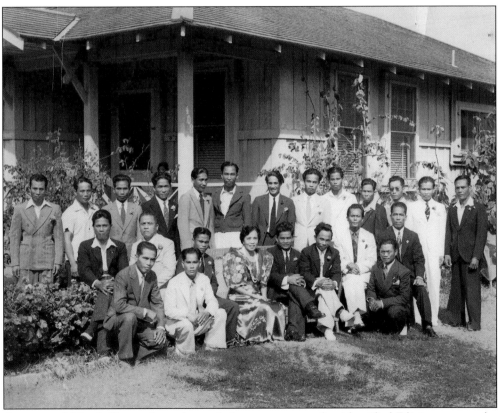

At a typical North Shore plantation-style home, a group of unidentified Filipino men and a matriarch are gathered in front. (Courtesy of the Lunasco family.)

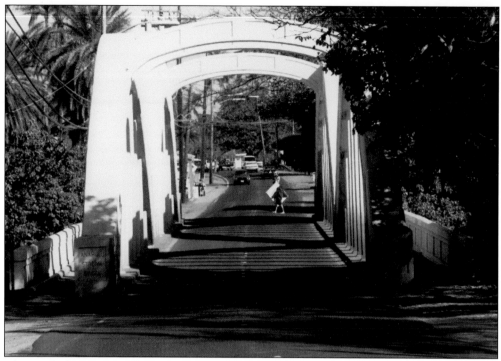

The Anahulu Bridge is shown on the Kamehameha Highway. This is a one of the main portals into Haleʻiwa. (Author's collection.)

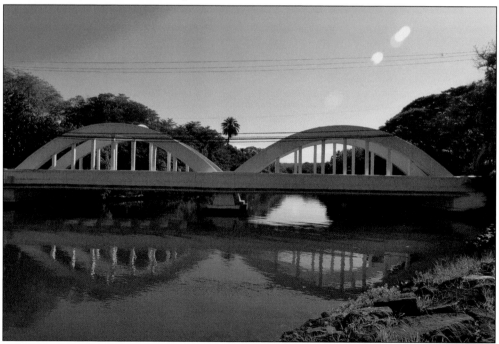

This is a side view of the Anahulu Bridge. This structure, built in 1921, has grown to become an icon for the North Shore. Two normal-sized cars can pass in opposite directions on the bridge—but just barely. (Author's collection.)

An unidentified Japanese grandmother and
her grandson stand in front of a Quonset
hut on the North Shore. (Courtesy of the
University of Hawai'i Oral History Program.)

Early plantation mechanization in the 1930s
helped ease the backbreaking labor tasks.
(Courtesy of the Hawai'i State Archives.)

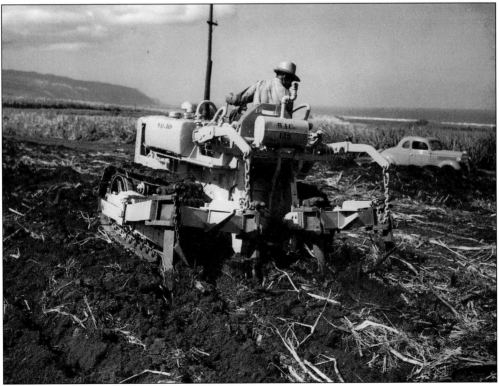

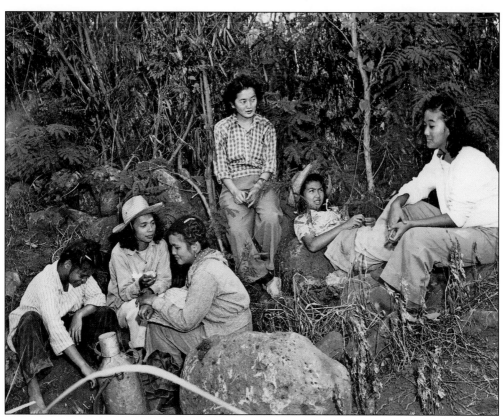

During World War II, students from the University of Hawai'i volunteered for service on the plantations. (Courtesy of National Archives.)

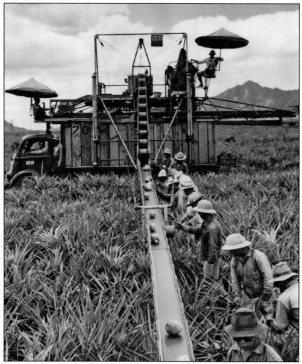

Even after mechanization improved production on the plantations, it was still necessary that human beings perform some backbreaking work. (Courtesy of the Hawai'i State Archives.)

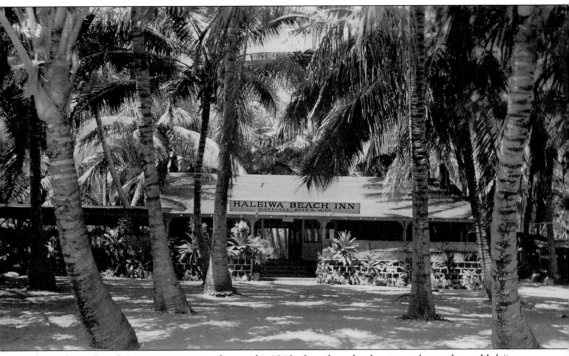

The Haleiwa Beach Inn was in service during the 1940s. It is thought that it was located near Haleʻiwa Beach Park near the old Holt Estate. (Courtesy of the US Army Tropic Lightning Museum.)

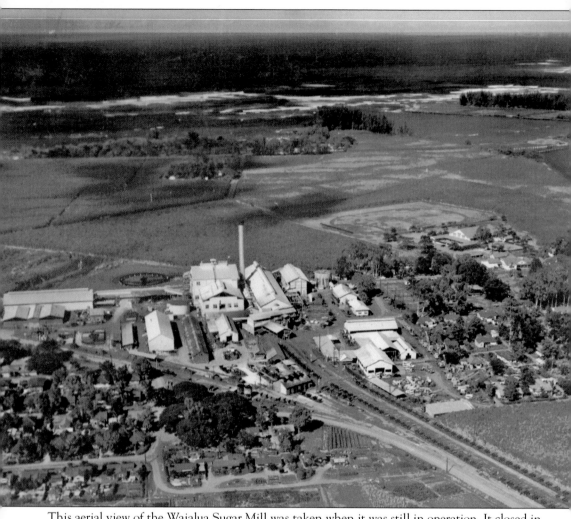

This aerial view of the Waialua Sugar Mill was taken when it was still in operation. It closed in October 1996. (Courtesy of the Hawai'i State Archives.)

# *Three*

# A WAVE OF WAR
## A MILITARY PRESENCE ON THE NORTH SHORE

By the turn of the 20th century, American business interests had succeeded in illegally overthrowing the Hawaiian monarchy, and the islands "officially" became a territory of the United States. By this time, the population was well on its way to becoming homogenized and forming the basis for Hawai'i's famous cosmopolitan society.

The North Shone was still a rather sleepy place, as evidenced by a demographic showing just 1,700 people living there in 1927. A sizable number of the Asian immigrant labor community returned home, either because they wanted to or were forced to, but at any rate fewer people were needed on the plantations due to mechanical advances. People in plantation camps accounted for most of the North Shore population, but there were also a smattering of Europeans and Americans in administrative positions. The remaining Hawaiians and newly arrived Portuguese who were involved in the capitalistic system gravitated to ranching, and the North Shore contained a number of cattle and horse ranches at this time.

What happened on December 7, 1941, would have an impact on not only the world and Hawai'i in general, but also specifically the North Shore. If the arrival of nearly 300,000 imported workers seemed like a stunning figure for such a small place, then modern readers can only imagine the impact of millions of American troops who came back and forth through Hawai'i on their way to and from the Pacific theater. World War II promised to vault the islands and the North Shore into another new age.

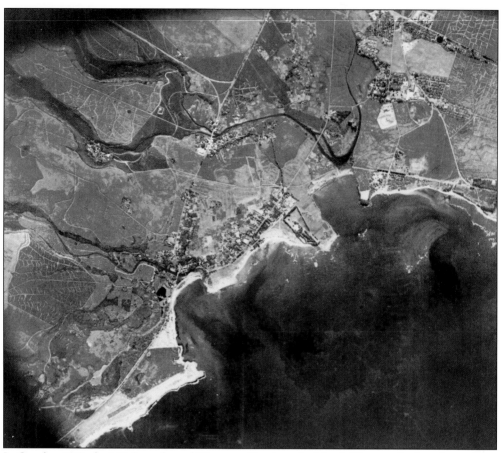

In October 1917, the US Army leased 39 acres of land on the North Shore at Pua'ena for artillery training. In 1933, an emergency airfield was established and used by the Army Air Force and was called Haleiwa Airfield. (Above, courtesy of the National Archives; below, Hawaii Aviation Preservation Society.)

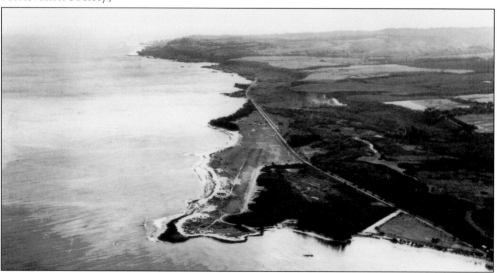

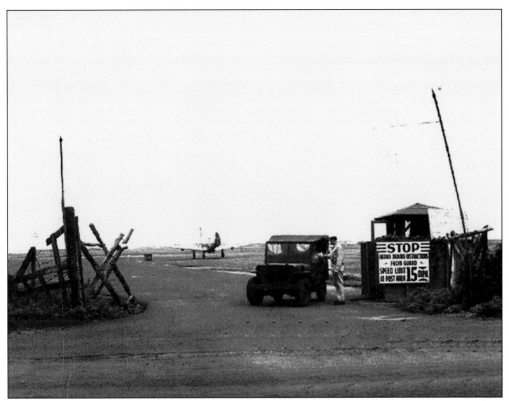

The main gate to the airfield is shown in the early days of World War II. (Courtesy of the National Archives.)

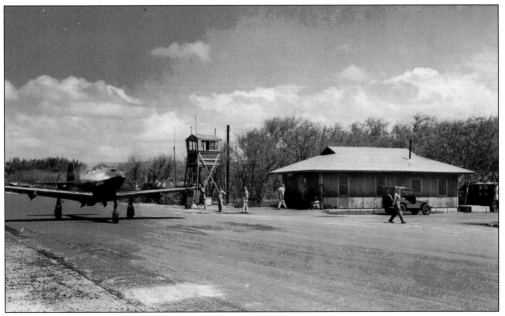

The control tower and ready room at the Haleiwa Airfield were constructed after the attack on Pearl Harbor. (Courtesy of the National Archives.)

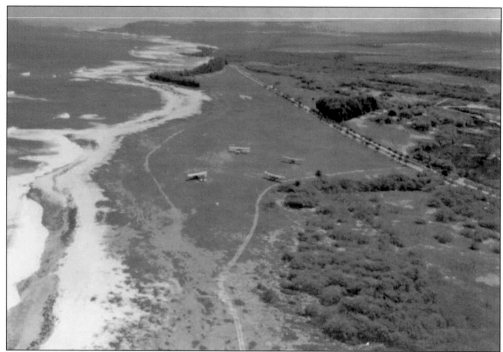

The airfield is pictured in the 1930s with biplanes on the sand runway. (Courtesy of the National Archives.)

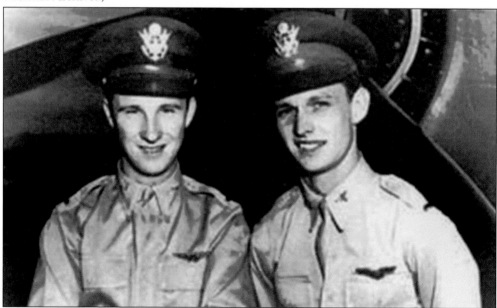

Young pilots assigned to the 15th Pursuit Group, 2nd Lieutenants Kenneth Taylor and George Welch (the latter a scion of the famous grape juice family), were stationed at Hale'iwa Airfield. On the morning of December 7, 1941, they were recovering from a night of partying at the Wheeler Officer's Club when the Japanese invasion took place. They raced the 10 miles to the Haleiwa Airfield, took off in their P-40 fighter planes, and shot down a total of six Japanese aircraft. Taylor was still wearing his tuxedo pants during this combat. (Courtesy of the National Archives.)

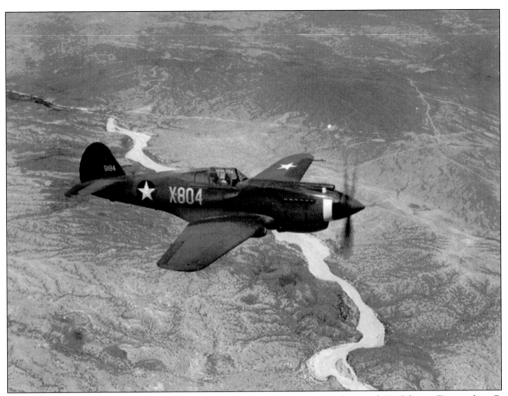

This P-40 Warhawk aircraft is similar to the ones flown by Taylor and Welsh on December 7, 1941. (Courtesy of the National Archives.)

Taylor and Welsh are pictured receiving the Distinguished Service Cross at an awards ceremony sometime after their heroics on December 7. Both men survived the war. (Courtesy of the National Archives.)

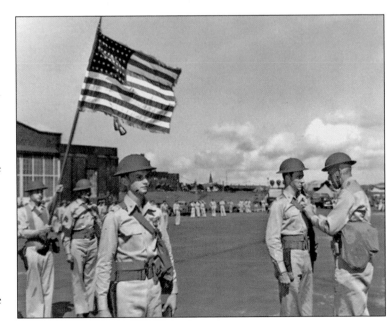

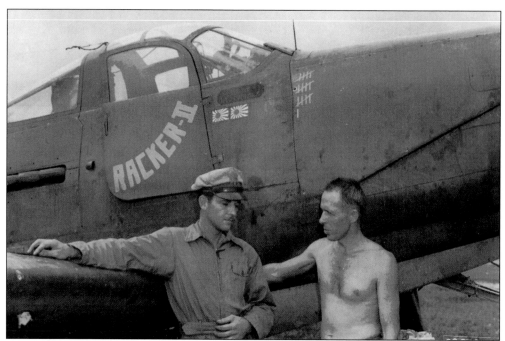

Stationed at Hale'iwa, an unidentified pilot and crewman pose in front of their fighter plane, which had seen combat service elsewhere in the Pacific. (Courtesy of the National Archives.)

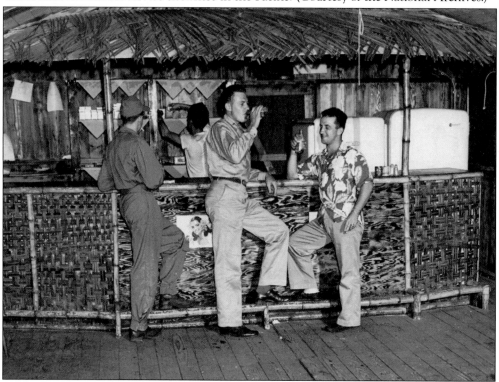

Airmen enjoy a cold beer at a refreshment facility on the Haleiwa Airfield during World War II. (Courtesy of the National Archives.)

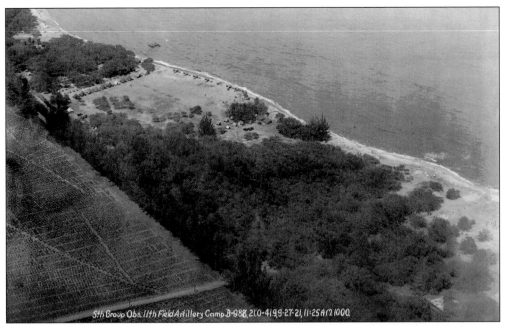

An Army bivouac at Hale'iwa is shown during World War II. (Courtesy of the National Archives.)

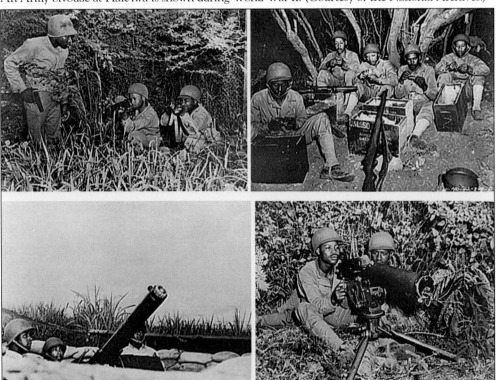

Antiaircraft batteries and other support installations for various North Shore military bases were provided when the 369th Coastal Artillery (AA) (Colored) Regiment arrived on June 21, 1942. The African American soldiers helped provide base support to defend the Opana Radar Station, Kahuku Army Airbase, and Haleiwa and Mokuleia Fields. (Courtesy of the Library of Congress.)

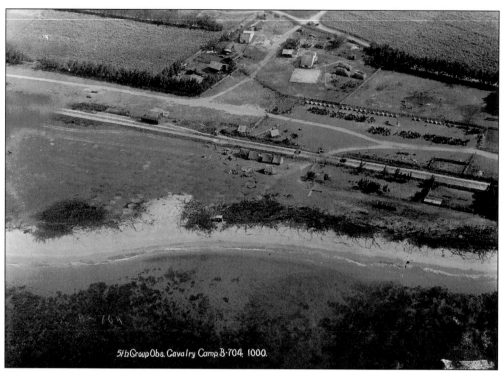

5th Group Obs. Cavalry Camp. B-704. 1000.

Cannon and antiaircraft emplacements were constructed near Hale'iwa. (Courtesy of the National Archives.)

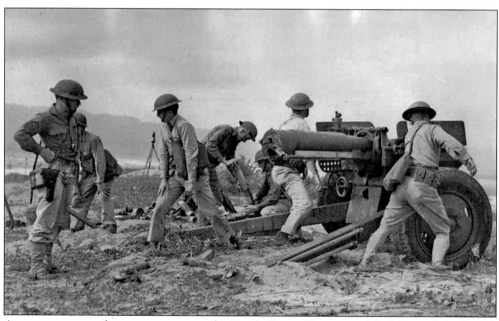

A cannon crew performs maneuvers on the North Shore. (Courtesy of the National Archives.)

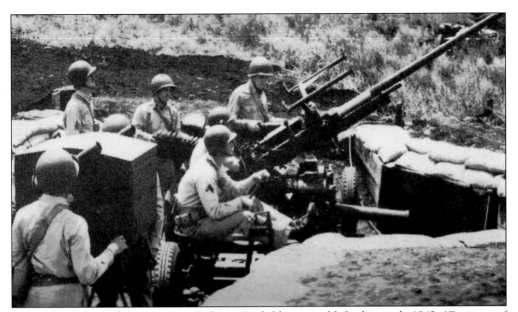

An antiaircraft emplacement near Haleiwa Airfield was established in early 1942. (Courtesy of the National Archives.)

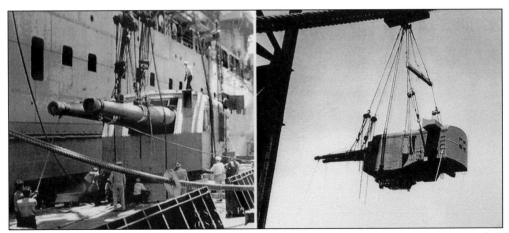

Large naval rifles are being removed from the aircraft carrier USS *Lexington* at Pearl Harbor during World War II. (Courtesy of the National Archives.)

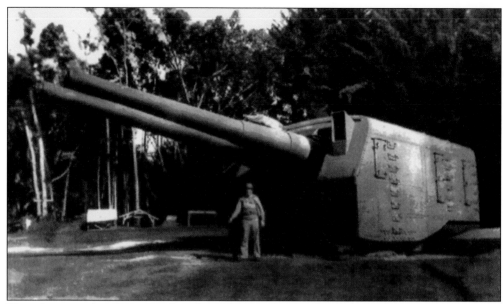

These large naval cannon were then shipped across the island of Oʻahu and up to Opaeʻula, which is located in the mountains two miles above Haleʻiwa. This photograph shows them in position at what was called Battery Riggs. (Courtesy of Richard W. Rodgers.)

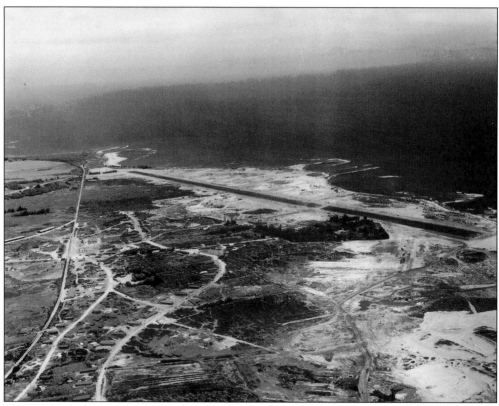

This is an aerial view of the military base at Kahuku. (Courtesy of the National Archives.)

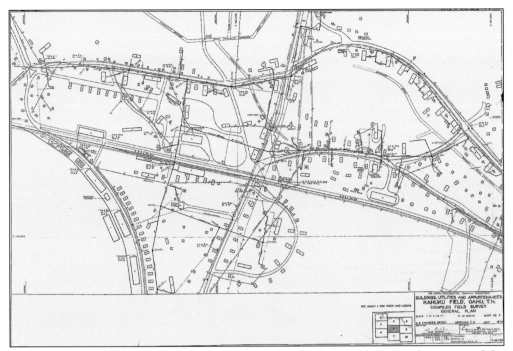

A military map depicts the Kahuku installation during the World War II. (Courtesy of the National Archives.)

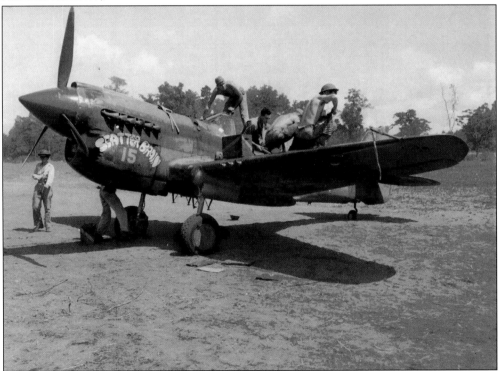

A P-40 fighter plane is being readied at Kahuku Airfield on the North Shore. (Courtesy of the National Archives.)

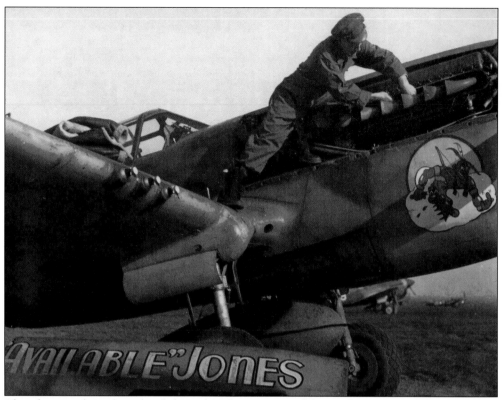

This photograph is of another fighter plane being prepared for combat. It was taken at Mokuleia Airfield during World War II. (Courtesy of the National Archives.)

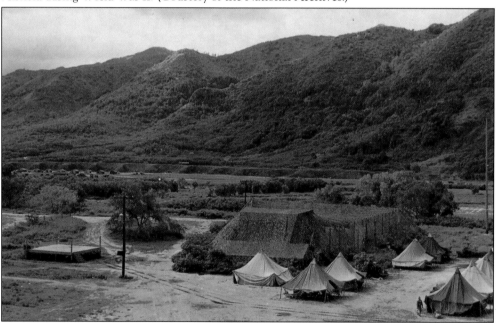

An army bivouac located near the Mokuleia Airfield is pictured during the World War II years. (Courtesy of the National Archives.)

This photograph shows the runway that was constructed at Mokuleia Airfield during World War II. (Courtesy of the National Archives.)

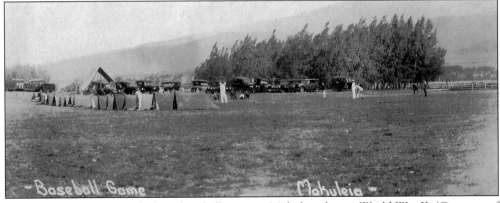

Army and Navy personnel play a baseball game at Mokuleia during World War II. (Courtesy of the National Archives.)

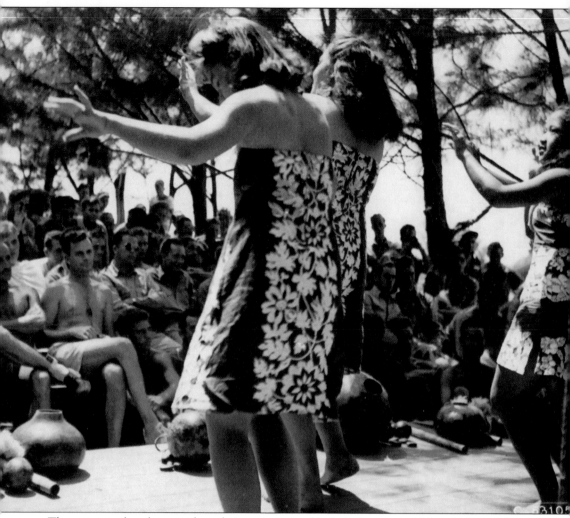

The troops in this photograph are being entertained by hula dancers at Mokuleia during the war. (Courtesy of the National Archives.)

# *Four*

# SURFING
## THE PERFECT WAVE

After the war ended, there was a slowdown in activity in Hawaiʻi, and this was particularly so on the North Shore. Some years later, soldiers still moved through nearby Schofield Barracks on their way to Vietnam, but the handwriting was beginning to show on the wall for the future of sugar and, to a lesser extent, pineapple. The plantation camps on the North Shore were closing, ranching activities were shutting down, and while Honolulu was about to experience an explosion of development and population, the North Shore once again became a part of the island of Oʻahu with only a few mom-and-pop stores and where children could play safely in the middle of the busiest road in "the country."

But something was happening in California that would have a refocusing effect on the North Shore. While surfing was certainly nothing new to the founder population, for it could be argued that Hawaiians almost invented surf riding, the early extreme sport notion of riding large, well-formed, and even dangerous waves was coming into vogue. It did not take long to realize that the North Shore of Oʻahu offered a practical selection of some of the finest big waves in the world.

Beginning in the 1950s, daring young men began showing up in the winter months to test their mettle against these natural giants, and for the past 50 years the numbers have been steadily growing. Now, thousands of men and women from around the world crowd the North Shore in order to surf waves of all sizes and enjoy a number of other water sports. There are many fine spots to ride waves around the world, but for many reasons the North Shore of Oʻahu is the jewel of them all and commands the world's surfing attention for several months every year.

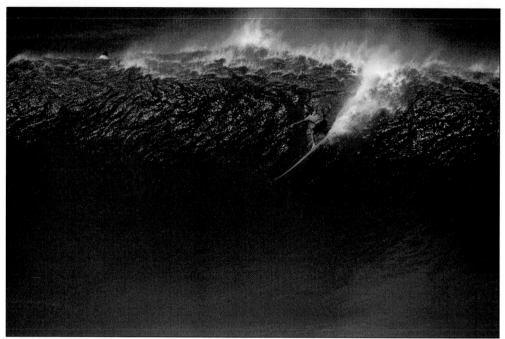

While there are many famous waves along the North Shore and many celebrated contests (not counting those massive waves where heroic experts need to be towed into them in a noncontest setting), the absolute premier surfing event in the world takes place when Waimea Bay's waves reach 20 feet or higher and are formed well enough to ride. (Courtesy of Quiksilver in Memory of Eddie Aikau.)

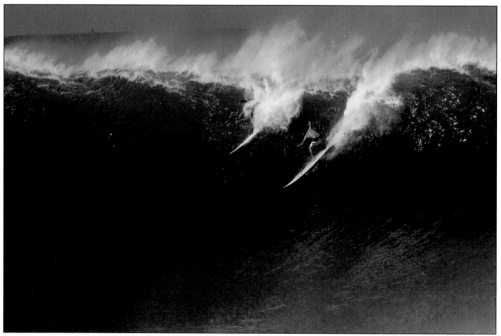

When Waimea Bay breaks at 25 feet, an incredible 25 tons of force per square meter is generated, and any mistake can take a life away. (Courtesy of Quiksilver in Memory of Eddie Aikau.)

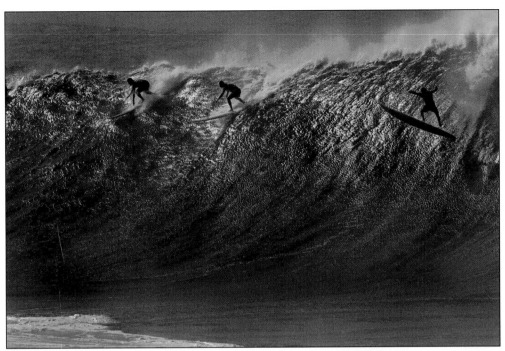

To get somewhere close to the feeling of what it is like to ride of one of Waimea's big waves, it is best to imagine standing on a large piece of plastic that is teetering atop a telephone poll that just happens to be travelling at 25 miles per hour, and then, with a great sense of timing, tipping the plastic platform down the side of the pole while trying to hold on. (Courtesy of Quiksilver in Memory of Eddie Aikau.)

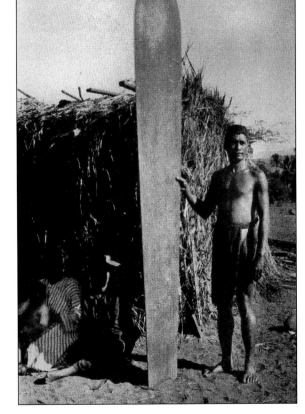

An 1800s photograph depicts an unidentified Hawaiian man and his surfboard. In those days, boards were sometimes 10 feet long, made of local hardwood, and could weigh 100 pounds. Any mishandling of a board such as this could result in death. (Courtesy of the Hawai'i State Archives.)

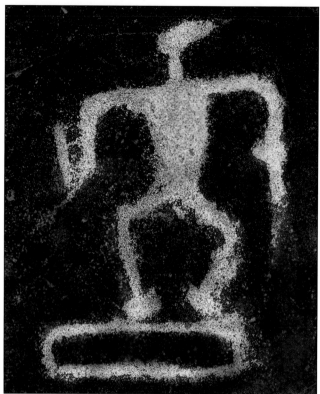

An ancient rock carving, or petroglyph, depicts a man on a surfboard. It is impossible at this time to know the exact date this image was engraved, but it most likely predates the arrival of Westerners and demonstrates the antiquity of Hawaiians' association with surfing. (Author's collection.)

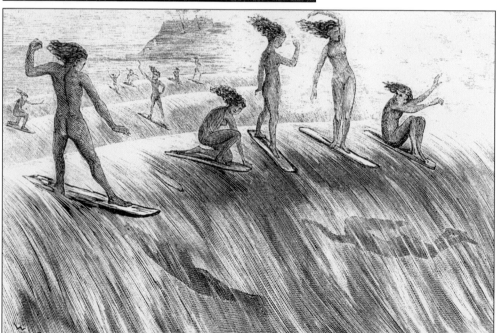

This etching appears to depict both men and women riding Hawaiian waves and their knowledge of the proper way to avoid being crushed by swimming under the break in order to regain outside position. (Courtesy of the Hawai'i State Archives.)

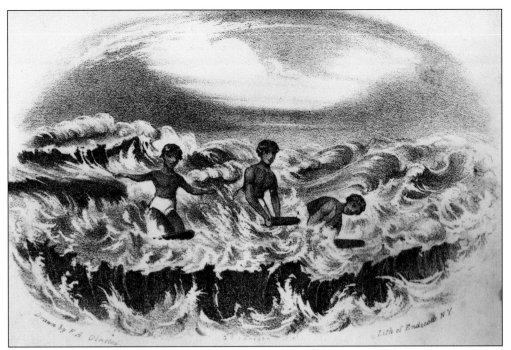

An early engraving depicts Hawaiians riding the surf on crafted planks of wood. While the Hawaiian people may not have been the first ever to ride waves, in their practice they certainly raised it into an art form by the time Westerners arrived in the 18th century. (Courtesy of the Hawai'i State Archives.)

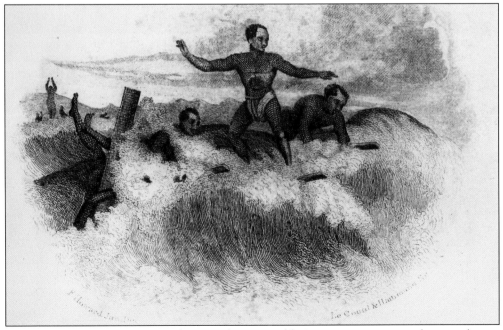

Even in ancient times, just a medium-sized wave could cause serious injury and required great skill to avoid disaster. It would, however, take another 100 years before exceptionally large waves were ridden. (Courtesy of the Hawai'i State Archives.)

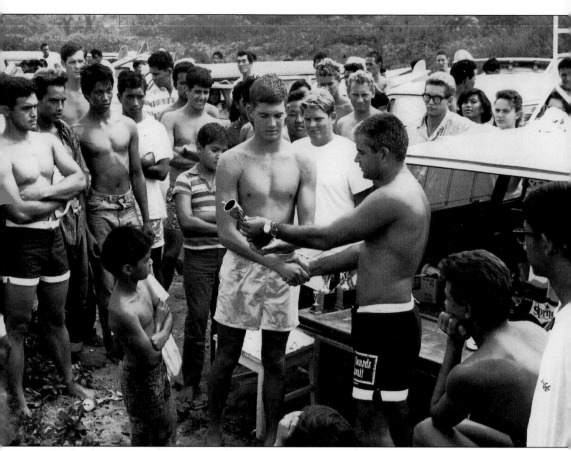

At this first-ever North Shore surfing contest, organizer and famous surfer Dick Brewer (black shorts holding the trophy) and his wife handed out modest trophies from the back of their station wagon. Today's winners of premier North Shore contests can make millions of dollars and are international celebrities. (Courtesy of John Clark.)

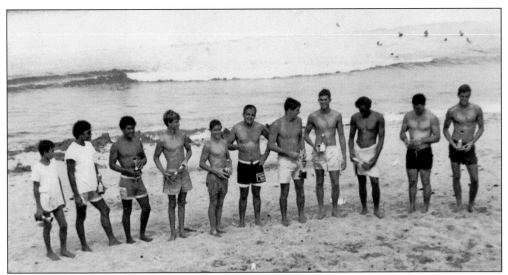

This photograph depicts the winners of the first surf contest ever held on the North Shore on November 29, 1964. Earlier contests took place in Waikiki and Makaha, but this one at Hale'iwa marked the beginning of a tradition that would grow to become one of the world's great sporting events and make the North Shore famous. The group photograph of includes, from left to right, (junior men's winners) no. 5, John Orr; no. 4, Frank Keuma; no. 3, James Bryant; no. 2, Jock Sutherland; no. 1, Jeff Hakmann, and Dick Brewer; (men's winners) no. 1, Butch Van Artsdalen; no. 2, John Clark; no. 3, Tiger Espere; no. 4, Fred Hemmings, and no. 5. Kiki Spangler. (Courtesy of John Clark.)

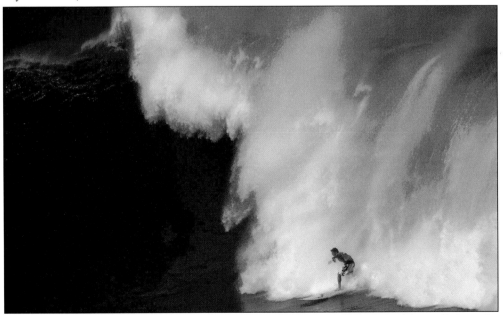

In the winter months, there are many waves of sometimes near perfect size and form all along the North Shore, and today contests are held at many of these breaks. The Triple Crown of Surfing winners ride at several locations to take home the coveted prize. One of these locations is at Pipeline, which creates at once some of the most beautifully formed and dangerous waves in the world. (Courtesy of Quiksilver in Memory of Eddie Aikau.)

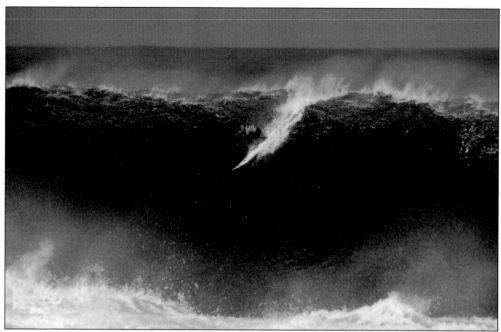

The modern way of measuring a wave is by estimating the height of its face. But that measurement has only been in vogue for the past several years in Hawai'i. Traditionally, the Hawaiian wave is measured from the back side, meaning a 20-foot Hawaiian wave has a face of 40 to 50 feet. (Courtesy of Quiksilver in Memory of Eddie Aikau.)

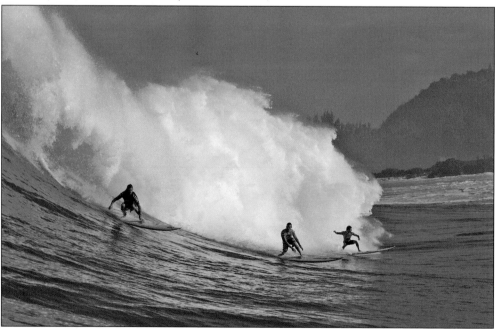

When considering Waimea's contest-surfing size of 25 feet and 25 tons of force per square meter, it is worthwhile to know that a wave measuring just 18 inches high can blast through a wall designed to endure a wind gust of 125 miles per hour. (Courtesy of Quiksilver in Memory of Eddie Aikau.)

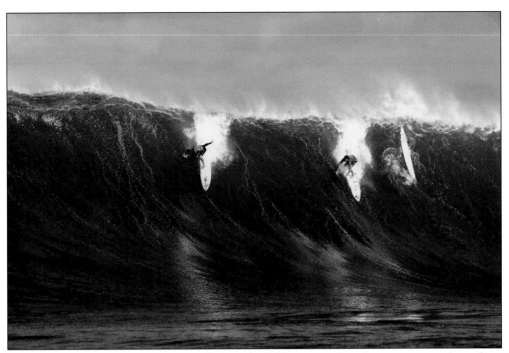

After local experts declare Waimea is fit for "The Eddie," invited surfers jump on airplanes from all over the world and come to the North Shore to participate. (Courtesy of Quiksilver in Memory of Eddie Aikau.)

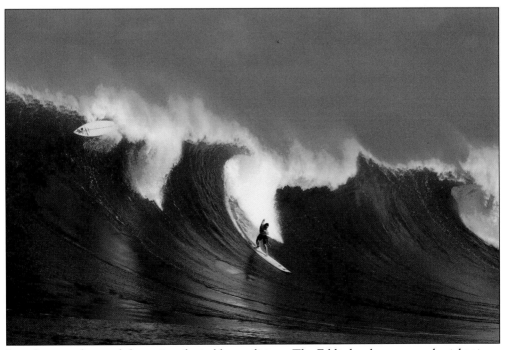

In order to understand the rarity of suitable conditions, The Eddie has been run only eight times in the past 26 years. (Courtesy of Quiksilver in Memory of Eddie Aikau.)

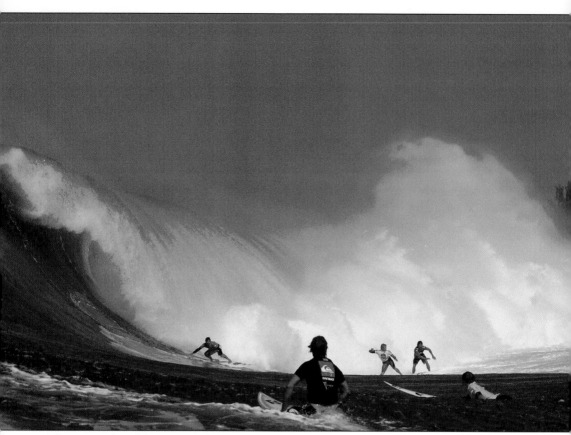

The namesake of this remarkable event was an equally remarkable waterman and lifeguard at Waimea Bay named Eddie Aikau, who lost his life while trying to save fellow crew members aboard the double-hulled canoe *Hokule'a* on its trip to Tahiti. (Courtesy of Quiksilver in Memory of Eddie Aikau.)

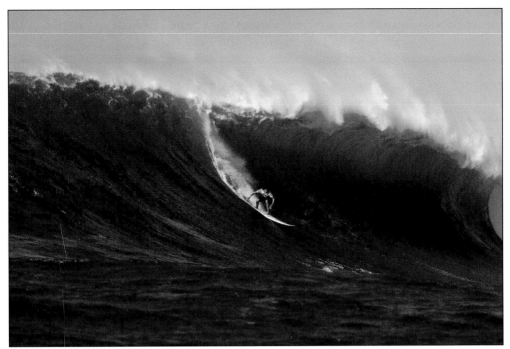

As best as anyone really knows, attempting to ride the large waves at Waimea and elsewhere on the North Shore is a phenomenon that only began in the late 1950s when technology and raw nerve permitted it. (Courtesy of Quiksilver in Memory of Eddie Aikau.)

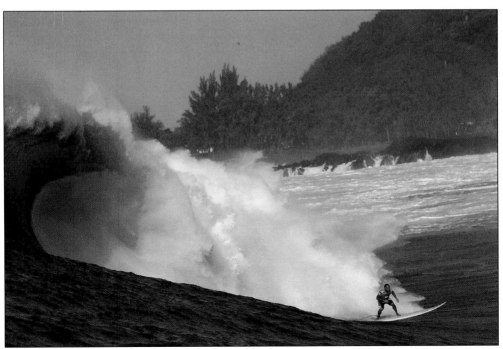

It is an event like none other in the world, and those few who can do it become addicted and never forget the experience. (Courtesy of Quiksilver in Memory of Eddie Aikau.)

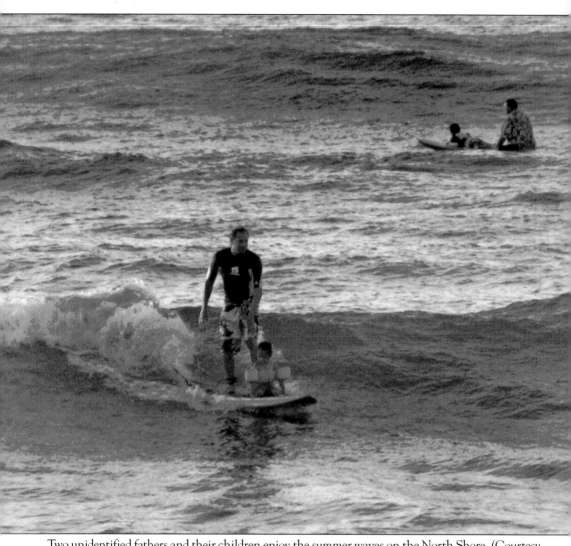

Two unidentified fathers and their children enjoy the summer waves on the North Shore. (Courtesy of Barbara Ritchie.)

# Five

# THE LATEST WAVE
## THE NORTH SHORE
## AND ADAPTIVE REUSE

As the population of Oʻahu grew to dizzying numbers in the last half of the 20th century, the North Shore remained relatively rural and experienced a growth rate that is only a fraction of that in other parts of the island. True to the nature, lifestyle, and mind-set of the place, its collective aim is devoted to keeping the North Shore "country," and those who live here today are in a struggle to keep it that way. An important part of this is the effort towards adaptive reuse and the push to choose meaningful, diversified agriculture over mass development. Adaptive reuse involves the adaptation of buildings that still exist here through careful and practical restoration and the promotion of agricultural activities on lands that have always been used to grow things.

There have been notable successes on the North Shore. Through considerable efforts on the part of the community, the Office of Hawaiian Affairs, the Audubon Society, and even the US Army, Waimea Valley was rescued from possible amusement park or private residence status and placed in reasonable preservation. The Trust for Public Land secured a very large prime parcel in the hills above many surfing beaches, and plans for responsible, preservation-in-perpetuity public use are underway. Individual landowners, such as the Pietsch family at Sunset Ranch, have followed suit.

Change is inevitable, of course, but studied and equable transformation is what is being called for on the North Shore. This is the continuum that pays respect to a place that has withstood many conversions and has managed to retain its distinctive character into the 21st century. There are not many places left like it, especially on the island of Oʻahu.

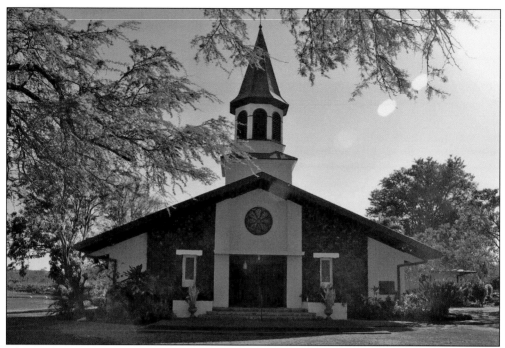

The modern Queen Lili'uokalani Church is shown in this photograph. This version of the church was constructed in 1890 and is the third since the first was built by Rev. Emerson in 1832. (Author's collection.)

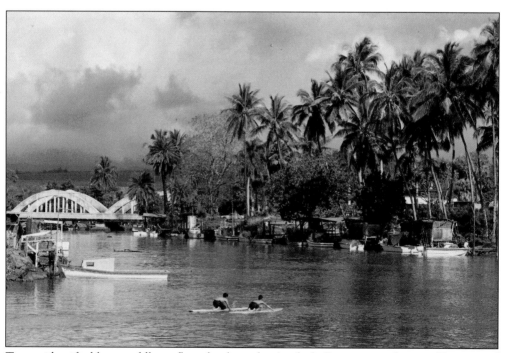

Two unidentified boys paddle surfboards where the Anahulu River meets the sea. (Courtesy of the Hawai'i State Archives.)

A Hawaiian church in Waialua that dates to the early 20th century is still in use every Sunday on the North Shore. (Author's collection.)

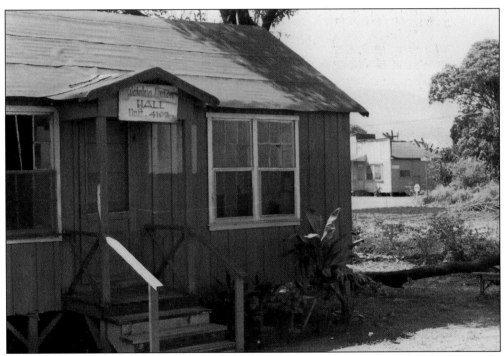

The Waialua Union Hall, Unit 4102 is pictured in the 1970s. In 1935, Pres. Franklin Roosevelt, as part of his New Deal legislation, passed the Wagner Act, giving workers the legal right to organize unions that could demand employer recognition. The International Longshoremen and Warehouseman's Union (ILWU) unified the former Japanese and Filipino racial unions into Hawai'i's biggest single union representing sugar, pineapple, and dockworkers across the island chain. (Courtesy of the University of Hawai'i Oral History Program.)

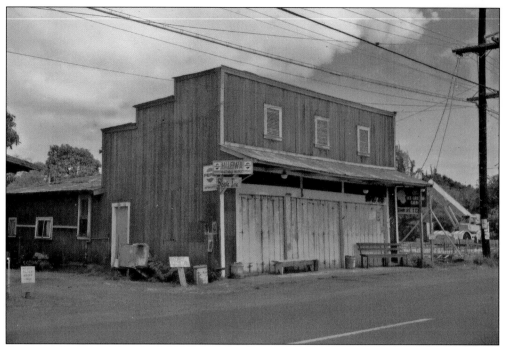

A currently unused building in Hale'iwa as it appears today reflects how the town has a tradition of not tearing down its old buildings but adapting them for reuse. (Courtesy of Hawai'i State Archives.)

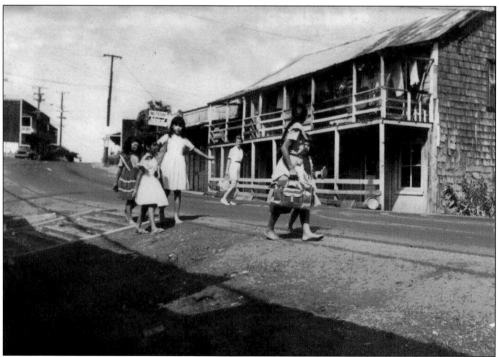

Children walk down a near traffic-free Kamehameha Highway in the 1950s. (Courtesy of Hawai'i State Archives.)

Jerry's Sweet Shop was a favorite stop for locals, military, surfers, and the few tourists who came to the North Shore in the 1960s and 1970s. Its structure was once a part of the original Sea View Inn across the road from Hale'iwa Beach Park. (Courtesy of the Matsumoto family.)

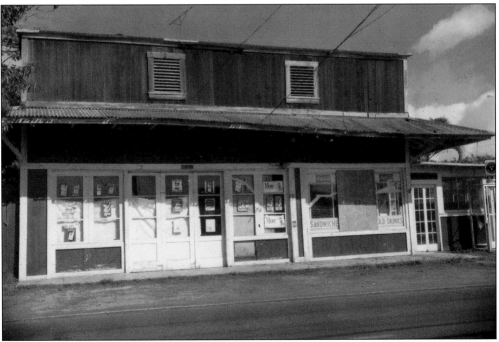

A Hale'iwa storefront is typical of nearly all the old buildings in town that were built by Japanese families who left the plantations to become entrepreneurs after the opening of the Hale'iwa Hotel. (Courtesy of Hawai'i State Archives.)

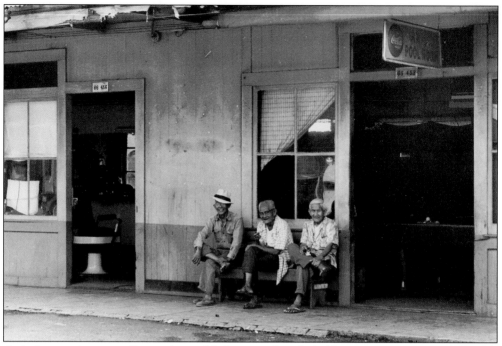

As is the case in towns all over the world, three unidentified old-timers swap stories on a bench in front of the pool hall and barbershop in the 1960s. (Courtesy of Hawai'i State Archives.)

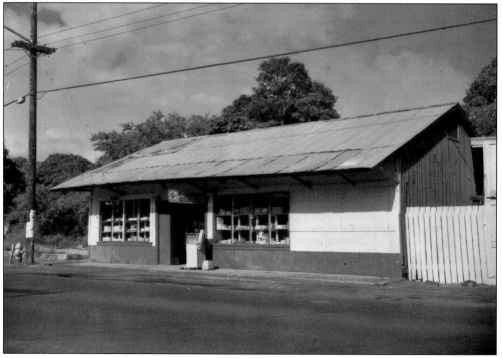

The Matsumoto Store is shown as it appeared in the 1950s. It is now the most popular place on the North Shore for "shave ice" and draws hundreds of visitors every day of the week. (Courtesy of the Matsumoto family.)

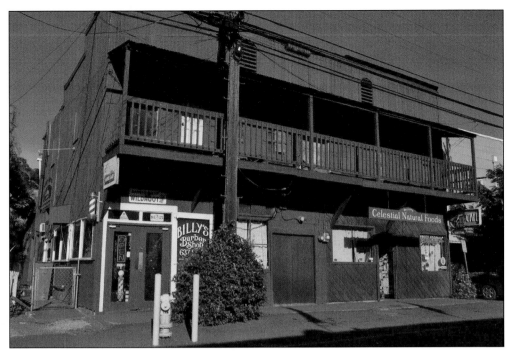

This building was constructed in 1917 as the Fujita Hotel and Coffee Shop and is now readapted as the home of Celestial Natural Foods and Billy's Barber Shop, which both retain the old-school feeling in their building and to the preference of their many clients. (Author's collection.)

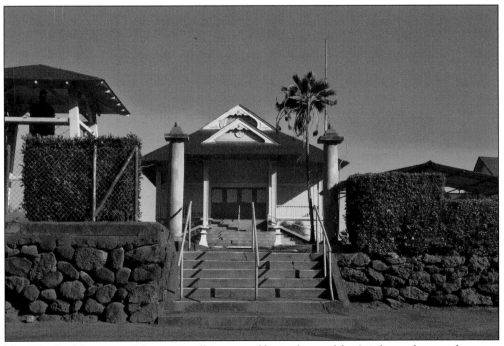

The Waialua Hongwanji Mission is still in use and lovingly cared for. It is located across the street from the old mill. (Author's collection.)

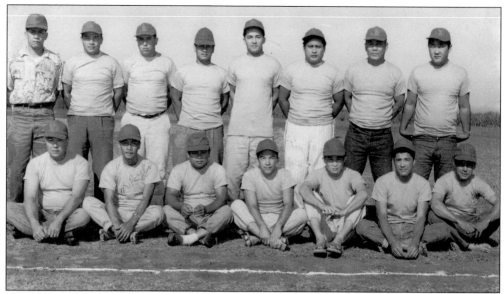

A local baseball team from the 1960s in Waialua is showing that sporting teams were integrated by this time and no longer formed exclusively along ethnic lines. (Courtesy of the Lunasco family.)

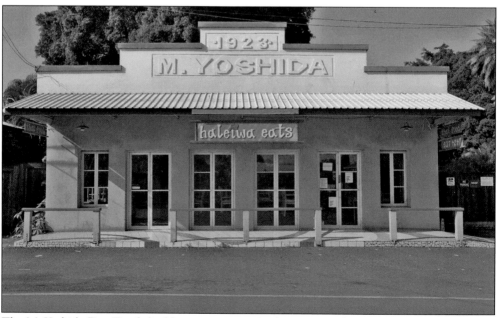

The M. Yoshida Dry Goods building was constructed in 1923 and is now enjoying reuse as the home of a Thai restaurant. (Author's collection.)

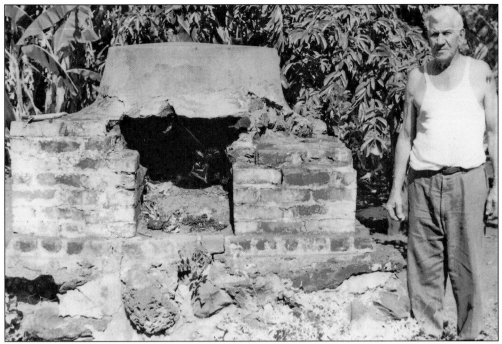

An unidentified local man stands before a traditional Portuguese oven in Waialua. He uses it today as his ancestors did before him. (Courtesy of the University of Hawai'i Oral History Program.)

The building on the left was constructed in the early 1920s and housed the Akiyama Photo Shop. It is now the Iwa Gallery. The building on the right is Aoki Shave Ice. It was established by Sumi and Michael Aoki in 1981. (Author's collection.)

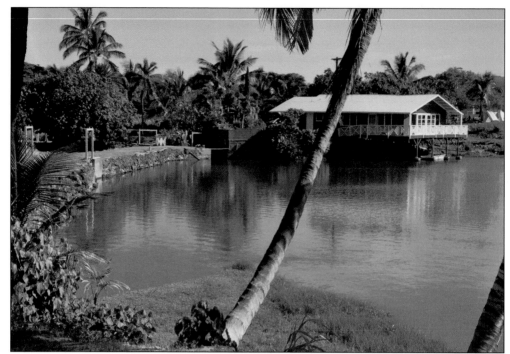

The Loko I'a Fishpond, which was constructed in the 1700s, is now being restored by Kamehameha Schools and is administered through the cottage on the banks of the pond. (Author's collection.)

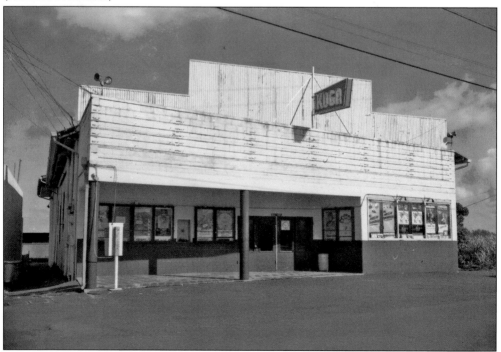

The Koga Store is one of many ongoing enterprises that continue to serve the residents of the North Shore in their original buildings. (Courtesy of Hawai'i State Archives.)

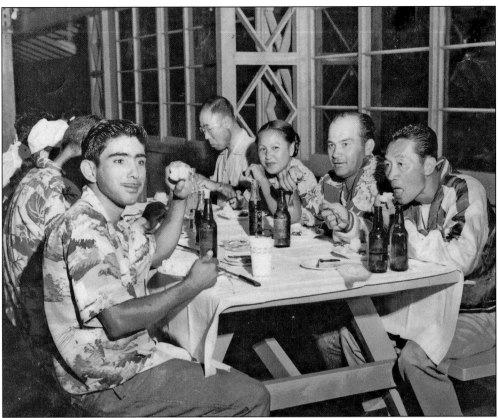

A group of local residents gathers for food, drinks, and friendship at Puʻu Iki Park in Waialua. Open-air pavilions and backyards are the preferred social venues on the North Shore. (Courtesy of the Lunasco family.)

Haleiwa Beach Park was formally known as Waialua Beach Park and was created in 1939. (Courtesy of Hawaiʻi State Archives.)

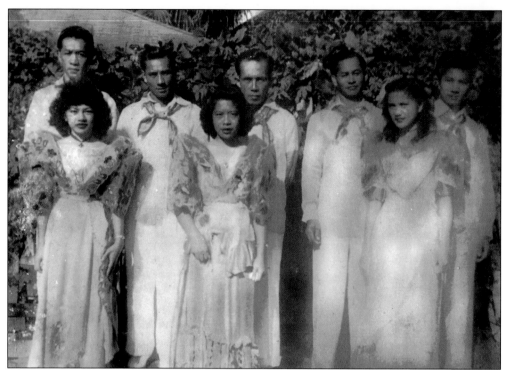

Once a year, the North Shore Filipino community has a fiesta that features traditional clothing and food. These folks are posing for the camera in the 1930s. (Courtesy of the Lunasco family.)

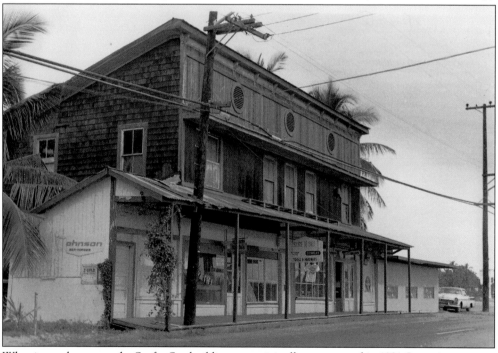

What is now known as the Surf-n-Sea building was originally constructed in 1921. Its various owners have been serving the needs of the surfing community for 40 years. (Courtesy of Joe Green.)

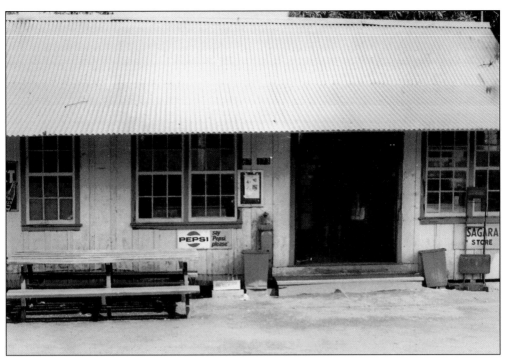

The Sagara Store was one of the most popular *okazuya* (in Japanese, a store that sells a variety of take-out foods) in Waialua. Generations of families have enjoyed their *shoyu* hot dog, fried rice, chow fun, potato tempura, gobo, sushi, and other local favorites. But sisters Colleen Mau and Claire Supebedia finally decided it was time to move on and for their parents, Harold and Kathleen Miyake, to retire. Colleen noted, sadly, in 2005, "Everything has changed; people are different now." (Courtesy of Hawai'i State Archives.)

The First Hawaiian Bank building served the plantation camps' population in Waialua for decades. It was later converted into the popular Sugar Bar, which hosted, at any one time, a variety of locals of all age groups—bikers, surfers, pets, polo players, military personnel, and even the occasional tourist. Live musical performances were conducted, adult refreshments were served, and a unique shuffle-of-the-deck clientele was always on hand. (Courtesy of Hawai'i State Archives.)

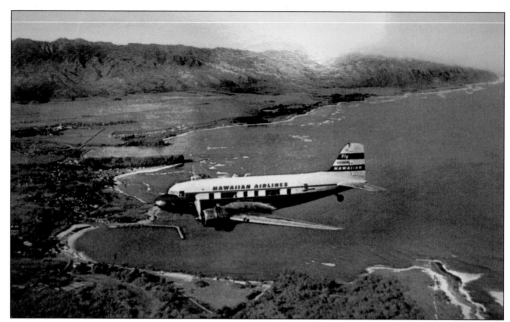

A Hawaiian Airlines plane flies over Hale'iwa, with much of Waialua in the background. Hawaiian Airlines was incorporated on January 30, 1929, under the name Inter-Island Airways Ltd. That year, the fleet was comprised of two eight-passenger Sikorsky S-38 amphibian planes. In 1941, Inter-Island changed its name to Hawaiian Airlines and introduced the 24-passenger DC-3 shown in this photograph. (Courtesy of Richard W. Rogers.)

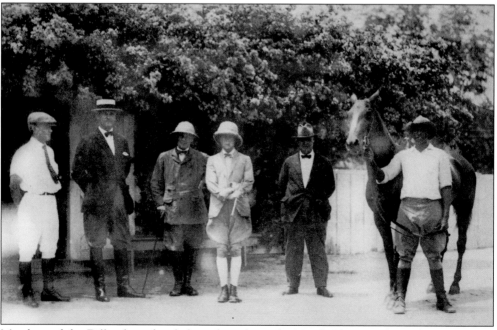

Members of the Dillingham family brought polo to the North Shore in the early 1900s. This popular tradition survives to this day under the care of three generations of the Dailey family. (Courtesy of the Dailey/Dillingham family.)

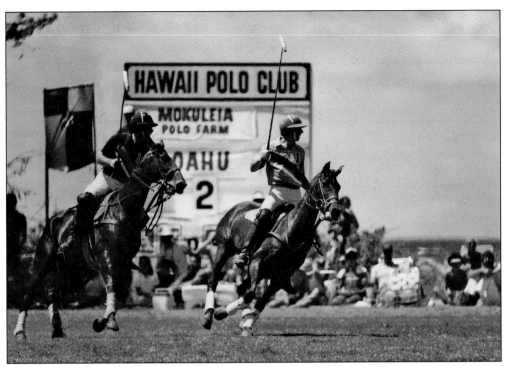

Polo action takes place on Sundays during the season near the Dailey Ranch at Mokuleia in Waialua and draws large crowds. (Courtesy of the Dailey/Dillingham family.)

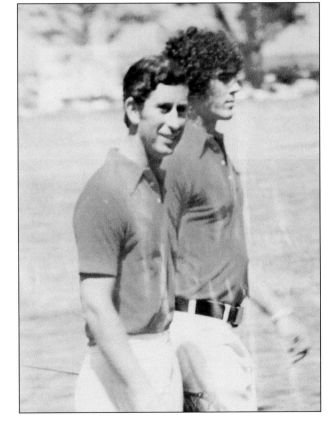

In addition to locals from all over the island, the Hawaii Polo Club also attracts some very celebrated players. Charles, Prince of Wales (left) walks with Mike Dailey after a match in the mid- to late 1970s. (Courtesy of the Dailey/Dillingham family.)

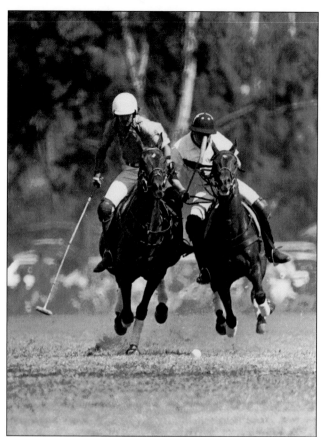

There is much action on the field as well as next to the field afterwards when players and spectators mix in the late afternoons at parties that feature live music, food, and good cheer—all courtesy of the Dailey family. (Courtesy of the Dailey/Dillingham family.)

The Sultan of Brunei (left) mixes with partygoers after a match. Hawai'i polo may be unique in the world because in this setting it is not at all impossible for the rows of spectators to rub shoulders with one of the wealthiest men in the world and hear Ginger Baker playing drums in the background. (Courtesy of the Dailey/Dillingham family.)

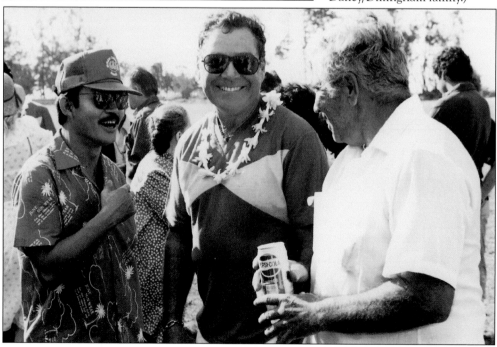

The beloved American humorist Will Rogers (left) poses with an unidentified member of the Dillingham family after a polo match in Waialua. (Courtesy of the Dailey/Dillingham family.)

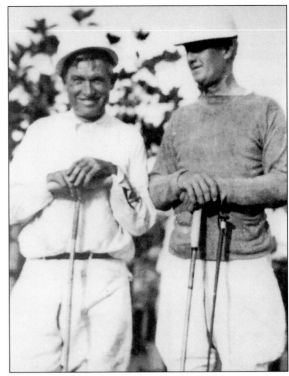

On the North Shore, it only takes a group of people of any age and a guitar to have an excuse for a party. (Courtesy of Hawai'i State Archives.)

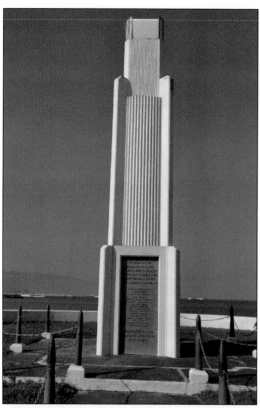

The War Memorial located in Haleʻiwa Beach Park was dedicated in 1947 and includes the names of North Shore soldiers killed in various wars. (Author's collection.)

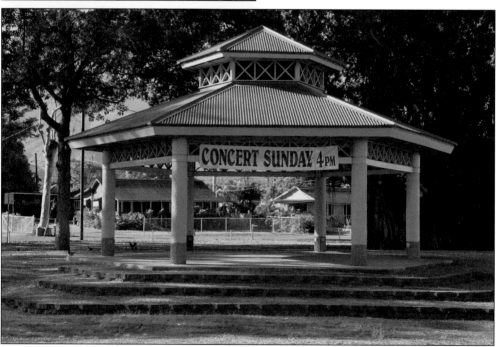

Located across the street from the library, a bandstand in Waialua is the venue for afternoon concerts of all types. (Author's collection.)

A selection of typical North Shore bungalows has been restored rather than torn down to make way for newer models. All are in use today. (Author's collection.)

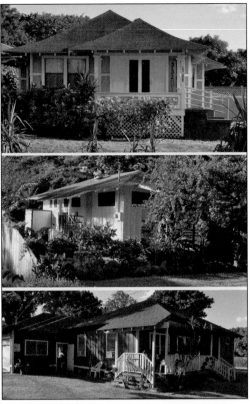

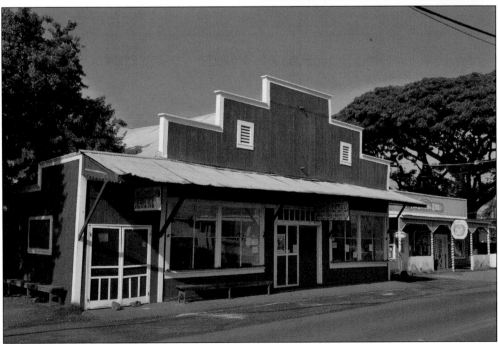

A plantation-era store in Hale'iwa that has been operational for over 90 years stands as a symbol of the North Shore mind-set. (Author's collection.)

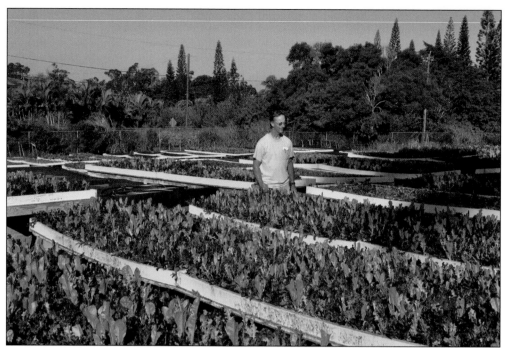

Backyard nurseries and small farms on the North Shore supply fresh produce to three farmer's markets that operate every weekend. (Author's collection.)

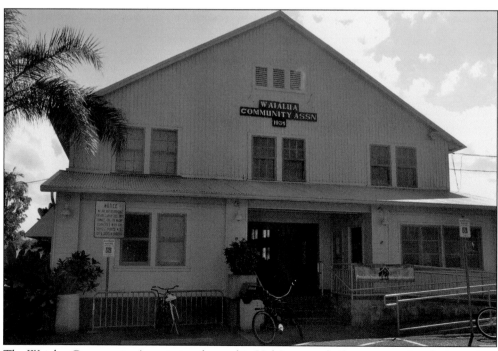

The Waialua Community Association, located in Hale'iwa, was built as a recreational gymnasium in 1937 and still serves the community in a variety of capacities. (Author's collection.)

The beautifully restored Mutual Telephone Company's Manager's Home now serves as the headquarters for the North Shore Chamber of Commerce. (Author's collection.)

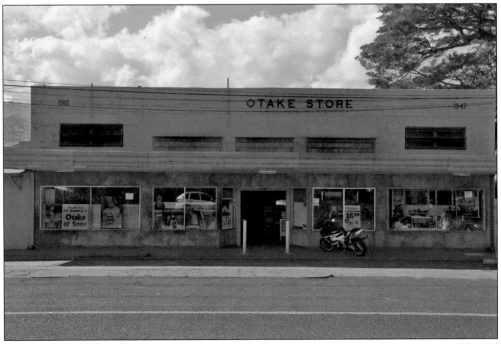

The Otake Store in Waialua is still open for business under the fourth generation of family management. (Author's collection.)

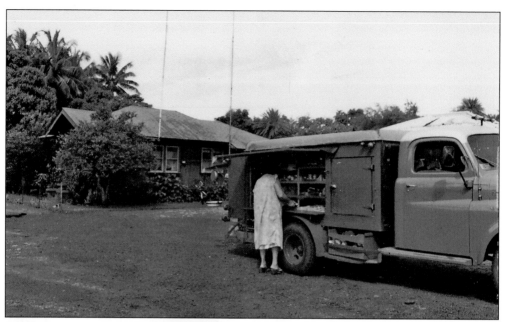

The "Manapua Man" made his rounds in the community selling a variety of local specialty foods from out of his truck to the residents. (Courtesy of Hawai'i State Archives.)

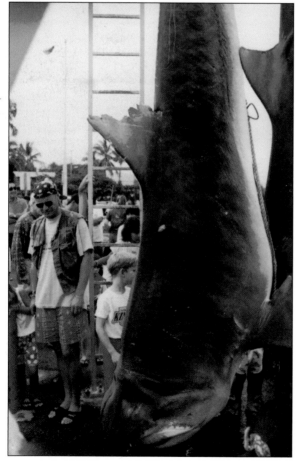

The Hanapa'a Jackpot Fishing Tournament takes place every year in Hale'iwa. Most of the participants are after ahi, ono, ulua, mahimahi, or other game fish. Occasionally, however, someone hauls in a monster such as this tiger shark. (Author's collection.)

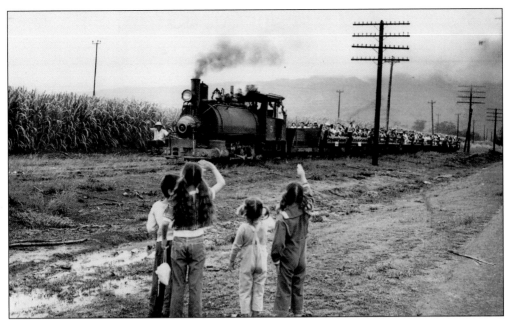

Children wave good-bye as the sugar train leaves the Waialua Mill for the last time. (Courtesy of Hawai'i State Archives.)

Virtually everyone who lives on the North Shore today would want the last caption in this book to read, "Keep the Country Country." (Courtesy of Richard W. Rodgers.)

# DISCOVER THOUSANDS OF LOCAL HISTORY BOOKS FEATURING MILLIONS OF VINTAGE IMAGES

Arcadia Publishing, the leading local history publisher in the United States, is committed to making history accessible and meaningful through publishing books that celebrate and preserve the heritage of America's people and places.

Find more books like this at
**www.arcadiapublishing.com**

Search for your hometown history, your old stomping grounds, and even your favorite sports team.